Cocktails, A Still Life

60 Spirited Paintings & Recipes

ART BY TODD M. CASEY

WRITTEN BY
CHRISTINE SISMONDO
& JAMES WALLER

RUNNING PRESS
PHILADELPHIA

Running Press
Hachette Book Group
1290 Avenue of the Americas, New York, NY 10104
www.runningpress.com
@Running_Press

Printed in China

First Edition: August 2022

Published by Running Press, an imprint of Perseus Books, LLC, a subsidiary of Hachette Book Group, Inc. The Running Press name and logo is a trademark of the Hachette Book Group.

The Hachette Speakers Bureau provides a wide range of authors for speaking events. To find out more, go to www.hachettespeakersbureau.com or call (866) 376-6591.

The publisher is not responsible for websites (or their content) that are not owned by the publisher.

Print book cover and interior design by Marissa Raybuck

Library of Congress Control Number: 2021944843

ISBNs: 978-0-7624-7518-6 (hardcover), 978-0-7624-7517-9 (ebook)

RRD-S

10 9 8 7 6 5 4 3 2 1

In memory of
Victoria Craven
(1958–2021)

Contents

Part One: Daytime Drinking...1

Part Two: Aperitivo Hour...35

Part Three: Cocktail Party...69

Part Four: Celebration...115

Part Five: After Dinner and before Bed...141

Acknowledgments

The work and support of many people made this book possible. First, we want to thank Martha Hopkins of Terrace Partners, Austin, TX, for her advocacy and commitment to seeing this project succeed. Second, we express our gratitude to the late Victoria Craven, to whom this book is dedicated. Todd's publisher at Monacelli Press and James's longtime employer and friend, Victoria gave us important tips as we prepared the proposal for this book. Our gratitude extends to the people we've worked with at Running Press, especially editor Jordana Hawkins, who has been an enthusiastic supporter of our project since taking it on in the summer of 2020, copyeditor Diana Drew, and book designer Marissa Raybuck. We'd also like to thank Kristen Wiewora, who saw the promise of the book at the outset.

Todd thanks his wife, Gina; his daughter, Scarlet; and his mother and father, Leslie and Albert Casey, as well as his gallerists Howard, Amy, Lance, and Alyssa Rehs. All the images of Todd's paintings appear courtesy of Rehs Contemporary Galleries, Inc., New York.

Christine thanks the many brilliant cocktail historians who have unearthed the obscure histories of our favorite refreshments. Also, of course, Myles, for always being there, and Allan, for all of the things.

And, finally, James thanks his husband and life companion, Jim O'Connor, who died in February 2021 as this book was being prepared for submission. For more than thirty years, Jim supported James in all his endeavors and James is blessed to have had such a person in his life.

Introduction

I had an uncle—a more or less constantly drunk uncle—who once confessed to me, "I don't drink for the taste. I drink for the effects." He was, unsurprisingly, very drunk when he said this. To hear it properly in your mind's ear you've got to imagine his words being slurred: *I doan drink for duh taysh. I drink for duh effeksh.*

Well, Uncle, don't we all—drink for the *effeksh*, that is? But there are those among us for whom the buzz of alcohol and the palliative care it so kindly delivers define *only part* of the appeal of drinking. For us, the taste—meaning the thousands of intriguing flavors that liquors possess, alone or in combination—matters enormously. That doesn't mean an affinity for alcoholic beverages isn't something people often have to work at acquiring, or that we don't all have our personal likes and dislikes. It just means that the sense of taste (and its more powerful partner, smell) is an essential contributor to the drinking experience.

But beyond the effects and the taste of booze, there's a third facet of drinking that I'd also identify as essential—what I'll call the *art* of drinking. Here, the term *art* covers a lot of territory and it bundles together very different sorts of non-gustatory pleasure. That includes the homey comfort—or the glitzy dazzle—of the places you like to go to drink. It includes the lore of drinking, which stretches prehistorically back past the Mesopotamian city-states and the Old Kingdom of ancient Egypt. It includes all the rigamarole—glassware and barware and hard-to-come-by ingredients—that sophisticated drinkers like to use, and, in some cases, to collect. It includes the friendships that commence with or grow deeper over drinks. And, of course, it embraces the mixological art itself—whether practiced by you as you make yourself a Manhattan or performed by a master bartender whose skills are mesmerizing to behold.

This art—this *fine art* of drinking—is what this book's about. Note, please, that the art doesn't have to be all fancy-schmancy. It can be as plainly pleasurable as sitting on a porch with a close friend, sipping Tom Collinses as a summer evening closes in. Or it can be as dramatic and thrilling as a glamorous cocktail party whose hosts have knocked themselves out on the

food, drink, and décor—*and* whose guests are all beautiful, dressed to the nines, and excellent conversationalists besides. (Granted, all that may be a tad much to hope for.) These are the kinds of experiences—humble or exalted, but engaging all the senses—that Todd Casey's still lifes and Christine Sismondo's reflections evoke and celebrate.

––––––––

Besides occasionally writing about drinks I also work as a freelance editor and for the past dozen or more years I've often edited art-instruction books. That's how I met Todd Casey—working with him on his first book, *The Art of Still Life* (Monacelli Studio, 2020).

To be frank, I'm sort of an art snob. I look at an awful lot of stuff and most of the stuff I look at fails the test of my discriminating—or, if you prefer, *cranky*—eye. A painting might be technically super-proficient—as so many artworks produced by contemporary classically trained realist painters are—while also feeling soulless, just a robotic exercise in fashioning an image that most people will automatically find "pretty" or even "beautiful." I don't have much patience for art of that sort, even if I admire the artist's skill. I want a work of art to teach my eye something it didn't know or to deepen my understanding of color, line, shape, composition—or representation itself. If, besides informing my eye, an artwork also moves me emotionally, so much the better.

Todd's work does all this for me, and I think it's the same for a lot of other people, as well. His sales figures would certainly indicate that he's doing something right. Of course, there's often a big difference between being a successful painter and being a *good* painter, but I don't see that distinction at work in Todd's case. I think people buy his paintings because they are moved by them. Yes, they look nice on the wall. But they also reward the viewer in a deeper way—and, in fact, telling a story in a way that imparts a mood or powerful feeling is part of Todd's intention as a painter.

Working with Todd on *The Art of Still Life* also showed me two other things, the first being hard to miss: A great deal of Todd's work focuses on alcoholic beverages and all the ceremonial paraphernalia involved in the making of cocktails. He likes painting drinks and he's especially adept at painting the transparent glass and shiny surfaces that appear in any realistically rendered picture of cocktails, wine, or beer.

The second: Todd is easy and fun to work with. So, given my experience in writing about drinks and Todd's interest in the subject and his talent and affability, it wasn't long before it occurred to me that he and I might work together on a book specifically about drinking—a picture-book of cocktail still lifes along with some text (not too much) to frame the visual presentation. It turned out that Todd had been thinking along the same lines and when we first discussed the idea we were both excited by the prospect of working together.

The book Todd and I envisioned wanted to come into being. And Todd *had to be the artist*—his paintings were the book's raison d'être. But I was having some health problems at the time and was reluctant to take on a sizable project. Then it dawned on me that the author didn't have to be me—or not me alone—and this realization cleared the path for the book you're reading now.

Christine Sismondo was the obvious choice for author. (She ended up writing most of the book and I basically served as her editor.) She and I had known each other for well over a decade—we'd met at the Tales of the Cocktail Festival in New Orleans in 2006, less than a year after Hurricane Katrina, when the city was still very much in recovery mode. Christine is a respected historian who's published a history of taverns in America from colonial times forward *(America Walks into a Bar: A Spirited History of Taverns and Saloons, Speakeasies and Grog Shops* [Oxford University Press, 2011]), as well as a journalist and lifestyle columnist with a fantastic sense of humor. And she knows an awful lot about booze without being at all pious about cocktail culture. (There are, unfortunately, a number of cocktalians out there who treat their hobby like a rigidly dogmatic religion, with infallible rules about how drinks are to be made, and served, and drunk. These people are not much fun.)

Christine *is* fun. She and I really like each other. We've gotten pleasantly inebriated together on a number of occasions. I especially recall one summertime get-together that started with lunch and drinks at a little bar/restaurant on lower Fifth Avenue in Manhattan and stretched far into the evening, ending at . . . well, I don't remember when or where we said goodnight. She and I had even talked once before about possibly working on a

book together—though nothing had come of that vague project. And, finally, I totally expected that she and Todd would get along well—which indeed turned out to be the case.

So I asked her and she said yes and the rest was gravy.

————

Gravy with *very few* lumps. Our extraordinary agent, Martha Hopkins—who took one look at Todd's paintings and decided that, yes, she did want to represent us on this project—found us a great publisher in no time flat and Christine and Todd worked like hell to complete the text and paintings within a reasonable proximity of their deadlines.

The only "problems"—enjoyable to solve!—concerned how to organize the book, which drinks to depict, the subject matter of the sidebars that would be scattered throughout the text, and the like. Having considered several other options (type of liquor, season of the year), we landed on "occasions for drinking" as the book's organizing principle. And within each of the book's five parts we aimed for as much variety as possible—not just diversity regarding the types of liquor used in the drinks and the drinks' places of origin, but also *visual* variety: What colors are the drinks? What kinds of glasses are they usually served in? What sorts of interesting props might appear in the pictures? In other words, we wanted the book to be as visually entertaining as possible, as well as amusing and informative. We think we've achieved that, but you, our readers, will have the final say.

James Waller
Baltimore

Where Inspiration Often Begins

When Frida Kahlo drank tequila, it was an act of rebellion—which fit in perfectly with the rest of her life. At the time, "authentic" Mexico wasn't in fashion. Mexicans who could afford it ate French and drank that way, too. That's changed, obviously, thanks in part to a long line of gringos who fell so deeply in love with the rustic beauty of agave spirits that they decided to get into the tequila business themselves. George Clooney comes to mind, of course, but he was hardly the first. That honor belongs to "White Christmas" crooner Bing Crosby, who in the 1950s started importing Tequila Herradura—the only 100 percent agave tequila available to Americans for decades.

Even though it's big business now and no longer truly a rebel's drink, tequila's still got a little street cred. It's for those of us who flirt with drinking on the wild side and appreciate its magical sparkle and raw, earthy essence—where inspiration often begins.

Daytime Drinking

Ever since the three-martini lunch fell out of fashion, day drinking has been on the wane. That's probably for the best, but it's worth noting that hoisting a glass before the sun goes down hasn't always been frowned upon. Most Puritans, for example, would have started their day with some hearty breakfast ale. Of course, they didn't have to operate as much heavy machinery as we do.

Although it's no longer a part of daily life, having a cheeky drink during the daylight hours once in a while is a distinct pleasure. Whether we're on vacation or have carved out a little free time to spend with friends on a patio, it's the perfect way to steal back some of the concessions we've made to modernity, which has all but banished day drinking from our lives.

Bloody Mary

Even if you don't like the drink, you should spend at least one afternoon in your life sipping a Red Snapper (aka Bloody Mary) at the King Cole Bar in the St. Regis Hotel in Midtown Manhattan—where it's sometimes claimed the drink was invented.

Whatever you call it, the concoction almost certainly was not created there. People have been spiking tomato juice with booze for almost as long as there have been hangovers. We don't really care how tenuous the connection is, though, since any excuse to imbibe in this elegant hotel bar while gazing at the astonishing thirty-foot-long Maxfield Parrish mural of Old King Cole is a good one. For the better part of a century, the Merry Old Soul has presided over the many bartenders who have mixed untold numbers of Red Snappers, none of them garnished with pickled beans or garish shrimp toppings—just a slice of lemon and a swizzle stick.

In a city where everyone complains that the old charm is quickly disappearing, the King Cole is a holdout. Enjoy it while you can.

SERVES ONE

* Lime wedge, for garnish
* Celery salt or other seasoned salt, for rimming the glass
* 2 ounces vodka
* 4 ounces tomato juice
* ½ ounce fresh lemon juice
* ¼ teaspoon fresh grated horseradish
* 2 to 3 dashes Worcestershire sauce
* ¼ teaspoon Tabasco sauce
* Salt, to taste
* Celery stalk, for garnish

Rim a highball glass with the lime wedge and seasoned salt and fill the glass with ice cubes. Combine the vodka, tomato juice, lemon juice, horseradish, Worcestershire, and Tabasco in a cocktail shaker with ice. Shake well and strain into the glass. Squeeze the lime wedge into the drink and drop it in. Salt to taste, stir briefly, and garnish with the celery stalk.

Corpse Reviver No. 2

The first thing you might well ask is this: What happened to the Corpse Reviver No. 1? It's alive and well. The original just isn't nearly as popular as the one that came after—a perfectly balanced and dangerously easy-drinking mix of gin, Lillet, Cointreau, and lemon juice, with a dash of absinthe.

Rediscovered a couple of years into the new millennium, the Corpse Reviver No. 2 is a perfect representative of the early days of the craft cocktail revival, which saw bartenders mine old cocktail books for inspiration and bring lost cocktails back to life. Of the 750 recipes in the *Savoy Cocktail Book* of 1930, this one just leapt out, not only because of its unusual name but also because it's one of only a handful that bartender Harry Craddock provided commentary on: "Four of these taken in swift succession will unrevive the corpse again." You just know there's a story behind that line. Unlike this terrific cocktail, though, it's lost to history.

SERVES ONE

* 1 ounce dry gin
* 1 ounce Cointreau
* 1 ounce Lillet Blanc
 (see recipe note)
* 1 ounce fresh lemon juice
* 1 dash absinthe
* Lemon twist, for garnish

Place all the ingredients except the absinthe in a cocktail shaker with ice. Shake well and strain into a coupe or a cocktail glass. Add the dash of absinthe to the finished drink. Garnish with a lemon twist.

Recipe note: The original recipe calls for Kina Lillet, a slightly bitter "tonic wine" that was eighty-sixed in, strangely enough, 1986. Most bartenders now use Lillet Blanc, a slightly sweet, orangey aperitif—a substitution that makes for a perfectly lovely drink. Some who are really keen on tasting the past have, however, doctored up their own Kina by infusing Lillet Blanc with bitter cinchona bark, the source for the quinine in tonic water.

Corpse Revivers, Fog Cutters, and Other Hangover Remedies

These days, people might joke about "breakfast wine" or hair of the dog, but we generally don't drink in the morning, except perhaps as a rare indulgence at brunch. In the nineteenth century, though, it was so common to pop into a saloon for an early-morning happy hour before you went

about your business that several names were coined for this "most important" drink of the day: fog cutters, eye openers, morning glories, phlegm cutters, bracers, and, of course, corpse revivers.

The main purpose of these drinks was, as the fog cutter's name implies, to cut through the fog caused by drinking too much the night before. And while any modern doctor will tell you that trying to drink away a hangover isn't advisable, it's a nearly universal home remedy. In Scandinavia and Central Europe, it's called a "repair beer." In many southern European countries, the idea of the morning-after drink is compared to a nail being used to pull out another nail—*chiodo scaccia chiodo*, as they say in Italy. Our favorite, though, has to be the Chinese ritual of partaking in a hangover cure known as "the drink that brings back your soul."

Bellini

Likely inspired by the age-old Italian tradition of preserving peaches in wine, the Bellini is a simple, elegant cocktail made with just two ingredients—peach nectar (or purée) and sparkling wine. Its inventor, Giuseppe Cipriani, owner of Harry's Bar in Venice, never went into detail regarding the ingredients, but he did explain the name. The drink's pale hue, apparently, reminded him of the color of a toga in a Bellini painting—peak Italian mythmaking.

So, if the bar owner's name was Giuseppe, who was Harry? That's another great story. Before opening Harry's in 1931, Cipriani tended bar at Venice's Hotel Europa, a favorite among wealthy Americans. One such, Harry Pickering, found himself less wealthy when his family cut him off and Cipriani kindly lent him enough lira to get home. It took Harry two years to return, but the next time he sat down at the Europa's bar, he paid Giuseppe back—with interest. Enough, in fact, for Giuseppe to open a snug little cocktail bar just off the Grand Canal, destined to become the "it" spot for all the usual literary barfly and café-society suspects and the birthplace of one of the world's greatest sparkling-wine cocktails.

SERVES ONE

* 2 ounces chilled peach nectar (see recipe note)
* 4 ounces prosecco
* Peach wedge, for garnish

Pour nectar into champagne flute. Gently top with prosecco. Garnish with a peach wedge.

Recipe note: When white peaches are available, seize the day and make the very best version of this drink: Pit and peel two ripe white peaches and purée them in a blender with half an ounce of lemon juice and half an ounce of simple syrup. Replace the peach nectar in the recipe above with the white peach purée. Refrigerate the purée, but use all of it within a day or two, even if this means you have to invite friends over to help you drink it. White peaches are highly seasonal, so take full advantage of this brief delicious window.

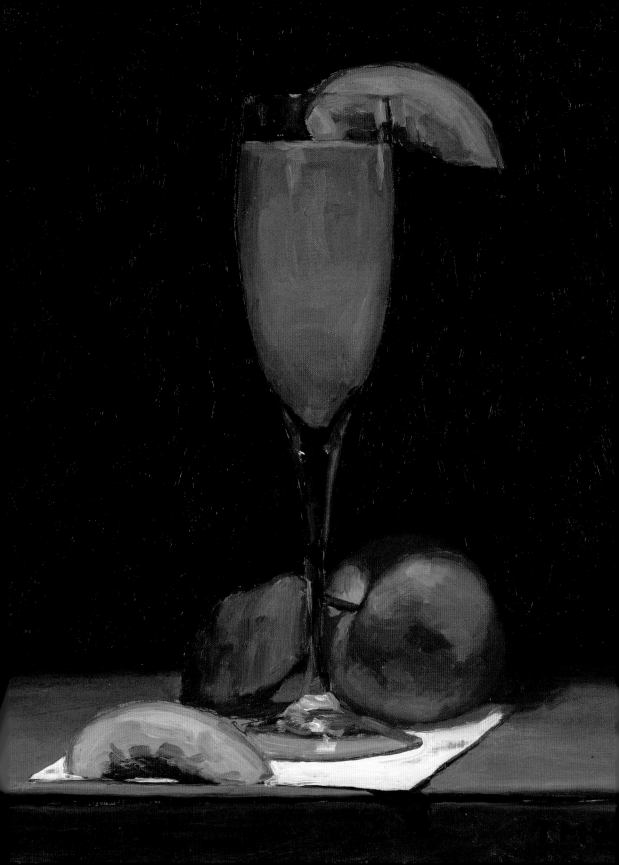

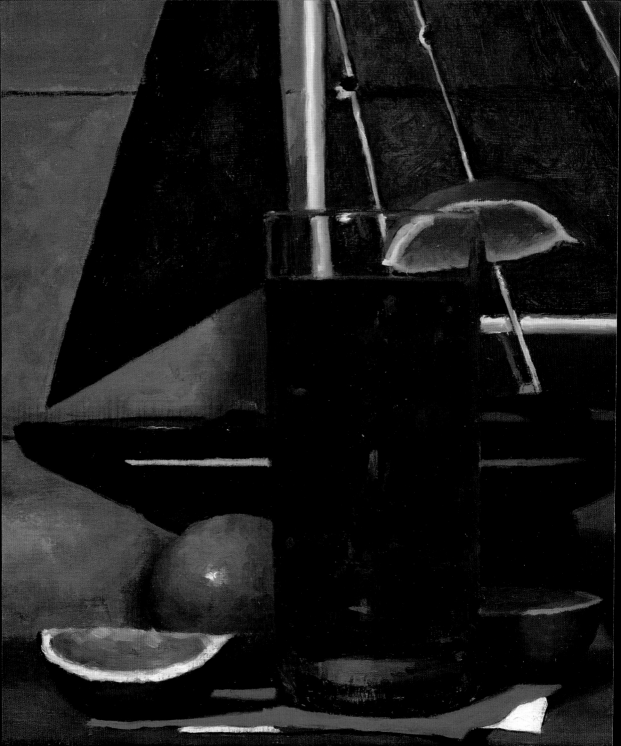

Dark 'n' Stormy

It's not uncommon for a drink recipe to suggest a specific brand of spirit. It's rare, however, to *require* a certain brand of liquor. Such is the case, however, with the Dark 'n' Stormy, a trademarked recipe that calls for Bermuda's own Gosling's Black Seal Rum.

Generally speaking, it's best not to indulge this heavy-handed sort of behavior, but Gosling's folks are pretty friendly about their claim. Their point is that, although they were hardly the first in the history of drinks to mix rum and ginger beer, the specific mix of Bermuda rum and local ginger beer is an integral part of Bermuda's quirky cultural identity. Christened the Dark 'n' Stormy roughly around the end of World War I, the drink is a major player in the Atlantic island's bar life and sailing culture—nearly as ubiquitous as those pastel-colored shorts that Bermudans wear year-round and on all occasions. (Really.)

In 1991 Gosling Brothers Ltd. decided to put a ring on it by filing (and winning) a trademark for the name and recipe, and since then the distiller has occasionally flexed its muscle when it's discovered another brand trying to use the name. In response, bartenders came up with a workaround: a new appellation—the Safe Harbor. We're sticking with the original Dark 'n' Stormy here, though, and not just for legal reasons—it's also a great drink.

SERVES ONE

* 2 ounces Gosling's Black Seal Rum
* 3 ounces ginger beer
* Lime wedge, for garnish

Fill a highball glass with ice cubes. Add rum and fill with ginger beer. Stir briefly and garnish with a lime wedge.

Piña Colada

As the cruise ship passengers pour into Puerto Rico's Old San Juan, a good number of them already have a destination in mind for their day-drinking pleasure: Barrachina's, the supposed birthplace of the Piña Colada, circa 1963.

Most day-trippers will never become aware that it's a contested origin story. At the other end of the peninsula, the Caribe Hilton—a groovy mid-century oceanfront hotel—boasts that a bartender at its Beachcomber Bar actually invented the Piña Colada some nine years earlier, in 1954. Even in the notoriously hazy world of cocktail history, that's a pretty big gap, given that the two bars are only two short miles apart. After all, drinks travel fast.

Who's right? Who cares! Both bars make a great drink. And both do a brisk trade off their ostensible bragging rights. More important is that Puerto Rico, which named the Piña Colada its official drink in 1978, gets credit for making an invaluable contribution to the world of cocktails.

The Piña Colada is the ultimate shorthand for "vacation mode." Even the act of ordering a Piña Colada can bring a smile to people's faces, *especially* if it's happy hour and the drinks are coming out two at a time. It doesn't matter where it originated or where you're drinking it. Wherever that is, you're on island time now.

SERVES ONE

* 5 ounces pineapple juice
* 2 ounces rum
* ½ ounce lime juice
* 1 ounce cream of coconut
* 1 ounce heavy whipping cream
* 1 cup crushed ice (see recipe note)
* ⅛ teaspoon salt (or less)
* Pineapple wedge, for garnish
* Amarena cherry, for garnish

Place all ingredients, except the fruit, in a blender and blend on medium for 60 seconds, or until the drink has a smooth, even consistency. Serve in a tulip glass with the pineapple wedge and an Amarena cherry for garnish.

Recipe note: Crushed ice is the secret to making a smooth blender drink with no lumps of ice.

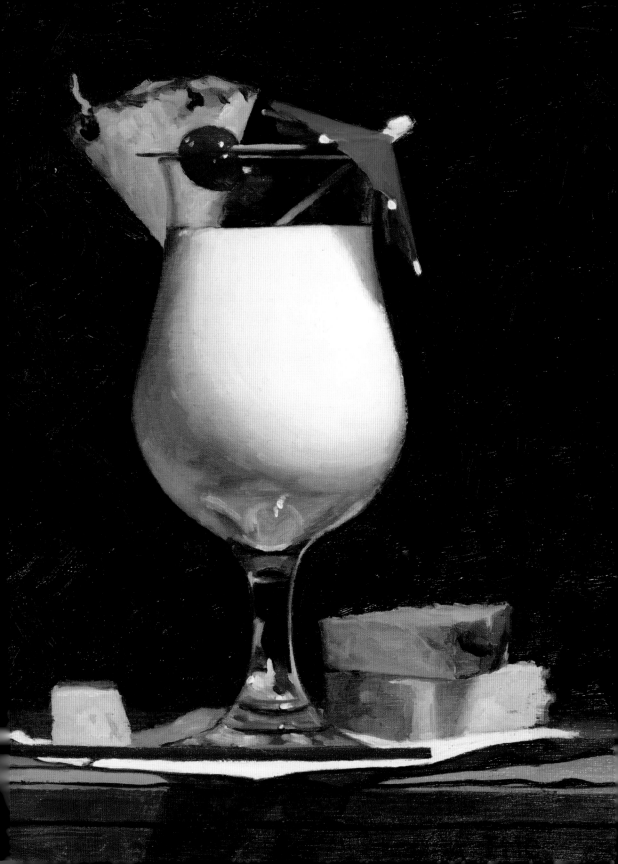

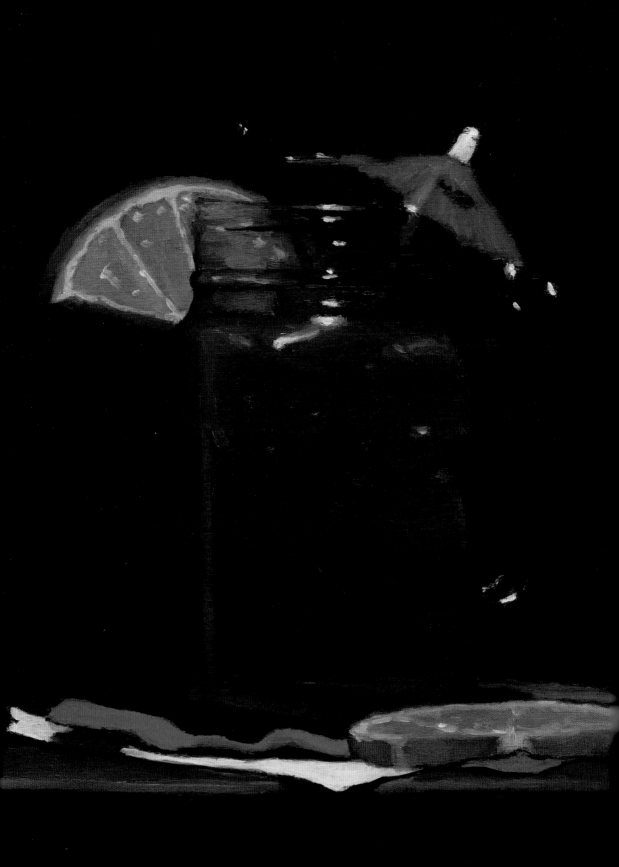

Rum, Ron, Rhum

Although a mounting pile of evidence now suggests that rum's birthplace is India (not, as previously thought, the Caribbean), most rum available on the market today hails from its adoptive home—El Caribe.

Speaking in broad strokes, this immensely varied liquor can be divided into three main styles—rum, *ron*, and *rhum*. Rum hails from former British colonies, such as Jamaica, Saint Lucia, and Barbados. Although these spirits are regionally distinct, they share some common traits, often tasting like ripe bananas and pineapple and tending to be a little spicier, heavier, and funkier than rums from other regions.

Ron—the name for rum from Spanish-speaking countries like Colombia, Puerto Rico, Cuba, and Nicaragua—tends to be light and sweet with muted flavors and tasting notes, making it ideal for tropical cocktails. Unlike rum and *ron*, which are both distilled from molasses, *agricole rhum* is made in the French Caribbean from freshly pressed sugar-cane juice, which makes for a distinct, fresh, floral, and lightly fruity spirit.

Queen's Park Swizzle

Outside the Caribbean, few people know how to properly swizzle a drink—a terrific mixing technique that gave birth to a whole family of drinks, including the Bermuda Rum Swizzle, the Green Swizzle, and the subject at hand, the Queen's Park Swizzle.

The key element that unites all these drinks is *le bois lélé*, a tool that originated in Martinique but quickly migrated to nearby islands and came to be known in the British West Indies as the swizzle stick. Not to be confused with the plastic garnish stir-sticks that first became popular in mid-century cocktail bars, the original swizzle stick was literally a twig plucked off a shrub, the *Quararibea turbinata*, whose branches jut out from the stem like the blades of a wind turbine. When you rub the stick between your hands, it does a great job of mixing up a slushy cocktail, sort of like a lo-fi immersion blender.

Perfect for a sultry day, the Queen's Park Swizzle was invented in the 1920s at the bar at the Queen's Park Hotel in Port of Spain, Trinidad, a swank resort that, sadly, no longer stands. Fortunately, the Queen's Park's minty swizzle, which Trader Vic called "the most delightful form of anesthesia given out today," has outlived its birthplace.

SERVES ONE

* 8 mint leaves
* ½ ounce Demerara syrup (see recipe note) or rich simple syrup (2 parts sugar to 1 part water)
* 3 ounces Demerara rum (see recipe note)
* 1 ounce fresh lime juice
* 4 dashes Angostura bitters
* Sprig of mint, for garnish

Gently muddle the mint leaves with syrup in a collins glass. Add the rum, juice, and crushed ice. Swizzle the drink with a *bois lélé* until it's a little slushy and nicely mixed. (In a pinch, a good barspoon can be used to swizzle the drink instead.) Add more crushed ice and the bitters and garnish with the mint sprig.

Recipe notes: Demerara rum—a small subcategory of British Caribbean rum—is rum made in Guyana; it's named for the Demerara River, which was integral to the development of the sugar trade in the country. The rum is sweet and rich in tropical fruit notes, ever-so-slightly funky, and, frankly, delicious. Dark, fruity rum from Jamaica, Barbados, or most other former British colonies (see "Rum, Ron, Rhum," page 15) can be used in place of Demerara rum, if necessary.

Demerara syrup makes this drink extra special, but rich simple syrup made with ordinary granulated sugar will work, too.

Belgian Beer

There's something about Belgian beer. No matter how the craft beer scenes in China, Ecuador, and everywhere in between have exploded, it's hard to sip on a gueuze, say, in a lively beer bar tucked off the Grand Place in Brussels and not come to the conclusion that the rest of the world is still playing catch-up.

That's hardly surprising, given that Belgium had a head start of roughly a thousand years, once the Catholic church gave permission to the monks in the abbeys to brew and sell beer as a way of raising funds. With that, the *bières d'abbaye* (abbey beers) were born.

In premodern Europe, it wasn't odd for the church to get into the beer business since fermented grains were considered healthful and were, in fact, far more potable than water. Abbey beers remain among Belgium's most cherished, representing the roots of the country's brewing traditions, but they are only one of many contemporary Belgian styles, which include everything from lambics, to bocks and tripels, to red ales, and, of course, the ubiquitous pilsner that is one of the country's more famous exports. You probably have your favorite, but thanks to the centuries-long history of brewing as a vital craft industry, many Belgian expressions are truly best in class. Although the painting depicts a simple pairing of ale and mussels, many beers also make a great base for beer cocktails, like the one below—a twist on the classic Champagne cocktail, the French 75 (see page 138).

Belgian 75

SERVES ONE

* 1 ounce gin
* ½ ounce simple syrup
* ½ ounce fresh lemon juice
* 5 ounces Belgian pale ale, golden ale, or Champagne beer
* Lemon twist, for garnish

Place all ingredients, except the beer and the lemon twist, in a cocktail shaker over ice. Shake and strain into a Champagne flute. Top with the beer and the lemon twist.

In early modern Europe, monastic breweries weren't unique to Belgium. By the seventeenth and eighteenth centuries, there were hundreds of relatively large breweries across the continent, all run by monks working to perfect their craft and raise money by selling their brews.

One region that was especially renowned for its cloistered ales was northern France, where La Trappe Abbey, home to an order of Cistercians of the Strict Observance, made first-rate refreshments for the locals. It may well have been the most fun thing the monks did, given their "strict observance" of the Rule of Saint Benedict, a sixth-century tract that requires followers to live their religion by adopting austerity and engaging in hard labor.

The French Revolution put a stop to all that fun in 1789, when the monasteries were destroyed and church property seized. This was in keeping with the view held by many revolutionary thinkers that monks, like aristocrats, were a class of loafers.

Rather than give up their hops-growing and beer-brewing, many Benedictines decamped to Belgium, bringing their expertise with them. Over two hundred years later, Trappist brewers are still having fun and making some of the best beer in the world. In 2016, UNESCO recognized their contribution by adding the Belgian beer industry to its list of the Intangible Cultural Heritage of Humanity.

Cape Codder

Depending on where you live, the Cape Codder might simply be known as a Vodka-Cran. Aside from a lime for garnish—and ice—vodka and cranberry juice are all that go into this simple mixed drink. Simplicity is one component of the success of the cranberry drinks that dominated the 1990s bar scene. The Sea Breeze, the Rose Kennedy, the Harpoon, and, of course, the Cosmopolitan (page 95) are all variations on a theme. But they were also more than that. Consumers were drawn to cranberry juice as a potential superfood and these drinks expressed a desire to drink a little more mindfully. An early wellness movement . . . of sorts.

That was good news for cranberry producers, who had been trying to convince the American public to mix their juice with booze since 1945, when they first introduced a vodka-cranberry drink. They were ahead of their time, but they missed the mark with the name they gave it—the Red Devil. When it comes to drinking for wellness, perception is everything.

SERVES ONE

* Lime wedge
* 2 ounces vodka
* About 5 ounces cranberry juice
* Lime wheel, for garnish

Rim a highball glass with the lime wedge and fill the glass with ice cubes. Pour in the vodka and cranberry juice and stir briefly. Squeeze the lime wedge into the drink and garnish with the lime wheel.

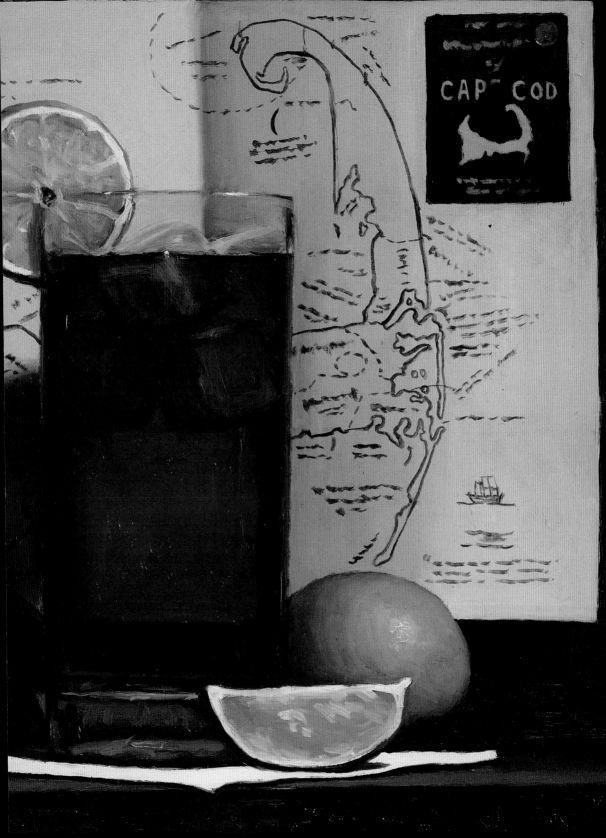

White Wine Sangria

Is *white sangria* a contradiction in terms? A paradox? An oxymoron? The word *sangria*, after all, derives from the Spanish word for *blood* and refers to the red wine that usually dominates contemporary versions of this charming and folksy Spanish pitcher drink. As near as we can tell, though, white sangria's bloodlines go back just as far. Young wine, no matter what its color, has often been rounded out with fruit.

Best enjoyed during the late, fleeting weeks of summer, a white sangria is a refreshing beverage, especially when it includes seasonal stone fruit (see the peaches variation in the recipe below). Sangria is surely an invitation to sit at an open-air table, sharing a pitcher with a friend as the long afternoon dwindles into evening.

SERVES FIVE OR SIX

* 1 lemon, cut into 4 to 5 thick slices
* 1 lime, cut into 4 to 5 thick slices
* 1 orange, cut into 4 to 5 thick slices
* Handful of raspberries, pitted cherries, or other small fruits (optional)
* ½ cup Cointreau
* 1 bottle fruity Spanish white wine, such as Verdejo or Albariño

Place the citrus slices and, if you're using them, the other fruits in a large glass or ceramic pitcher and pour in the Cointreau. Carefully muddle the fruit and liqueur, smashing the fruit slightly. Add the white wine and stir. Refrigerate for 1 to 2 hours. Add a tray of ice cubes to the pitcher and stir again before serving.

Recipe variation: Substitute two large, very ripe peaches (pitted, peeled, and cut into wedges) for the citrus and other fruits. Place them in the pitcher, pour in the Cointreau and wine (do *not* muddle), and stir. Refrigerate for 1 to 2 hours. Add the ice cubes and stir again before serving.

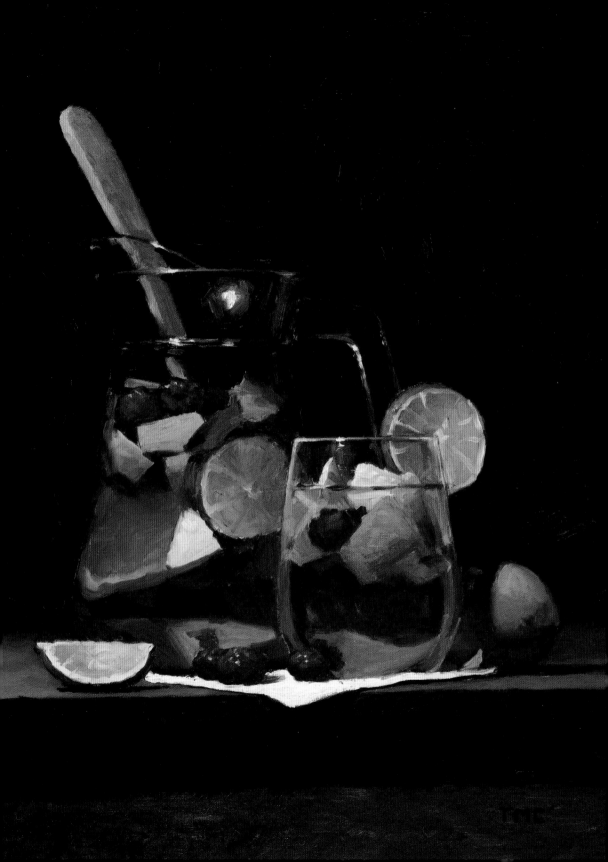

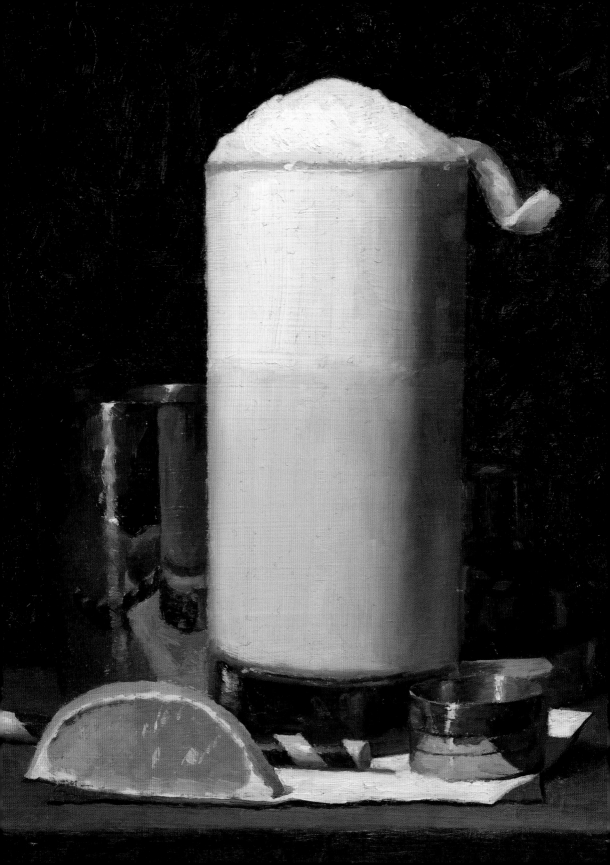

Ramos Gin Fizz

With all its fanciful descriptors and whimsical tasting notes, cocktail writers' prose can border on the absurd, but it's no exaggeration to call the Ramos Gin Fizz a thing of ethereal beauty. That's even more exceptional when you consider that the drink is made by shaking together an unlikely-sounding list of ingredients— cream, egg white, orange flower water, gin, and juice. But the Ramos proves that sometimes the whole really is greater than the sum of its parts.

The Ramos hails from New Orleans, where it was invented in 1888 at the Imperial Cabinet Saloon, whose owner, Henry Charles Ramos, took social responsibility extremely seriously. "Brother" H. C. Ramos closed his saloon early in the evening and always made sure that his patrons didn't overdo it. Such commitment would be uncommon for a barkeep in any era, but it qualifies as a unicorn in boozy nineteenth-century NOLA.

Of course, it would be hard to get too tipsy if all you were drinking were Brother Ramos's Gin Fizzes, given how long you had to wait for one to be made: The Imperial Cabinet's fabulous "shaker boys" were required to shake each drink for twelve whole minutes to get the perfect foamy top. (Modern recipes only call for three minutes of shaking, presumably because we don't want to die of thirst while we wait.)

SERVES ONE

* 2 ounces dry gin
* 1 ounce heavy whipping cream
* ½ ounce simple syrup
* ¼ ounce fresh lemon juice
* ¼ ounce fresh lime juice
* 3 drops orange flower water
* 1 egg white
* Club soda
* Lemon twist, for garnish

Combine all ingredients except the club soda in a cocktail shaker with ice and shake well for three full minutes. (Wrap the shaker in a towel, because it will become very cold.) Strain into a tall collins glass and top with club soda to make that beautiful frothy head. Garnish with a lemon twist.

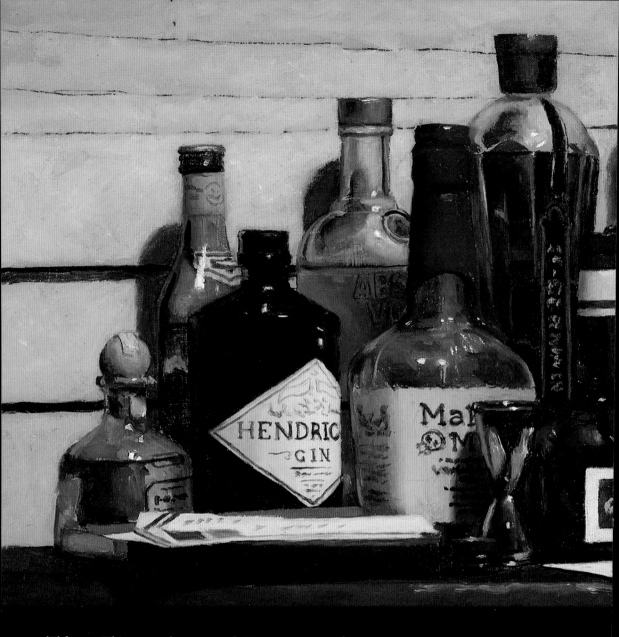

The Fine Art of Bartending

From tavern-keepers in ancient Pompeii to Brian Flanagan in the movie *Cocktail*, the barkeep holds a special place in our cultural imagination. No wonder, since it takes a special kind of personality to handle a roomful of people, making sure everyone is constantly refreshed but never over-refreshed. On top of that, beginning in the mid-1800s, a number of bartenders decided to throw another ball in the air by creating their own cocktails.

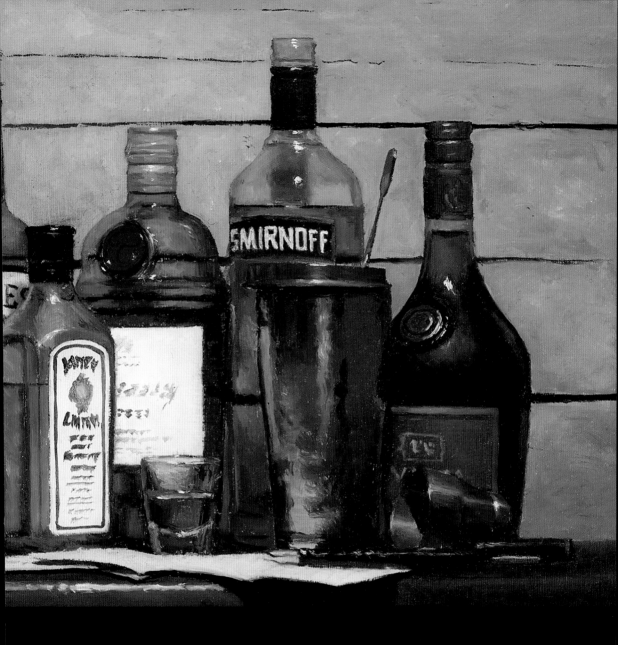

By far the most famous of these nineteenth-century bartenders is Jerry Thomas, who not only concocted recipes still used by contemporary craft cocktail bartenders but was also known for his flashy outfits and theatrical bartending style. He perfected bar tricks such as "throwing" his cocktails (pouring them back and forth between shakers in long streams), especially the Blue Blazer, which was lit on fire before the throwing began. P. T. Barnum had nothing on Jerry Thomas. Neither, for that matter, does Tom Cruise.

Tom Collins

"Have you seen Tom Collins?" was a question that went viral in the saloons and taverns of New York and Pennsylvania in 1874. Folks who were asked the question were usually confused and started searching back through their memory to see if they could recall an acquaintance by that name. That's when the prankster would hit them with the wallop: "Well, Tom Collins sure seems to know you. He was just talking about you at the saloon around the corner—and none of what he was saying was too good." The victim would then jump up and run to all the local bars in search of this slanderous Tom Collins.

One wise bartender, the justly famous Jerry Thomas, came up with a way to comfort the victims of this nuisance scam. He served them a drink named after the Great Tom Collins Hoax. The recipe was first printed in the 1876 edition of his *Bar-Tenders Guide: How to Mix All Kinds of Plain and Fancy Drinks*. Other similar drinks had appeared earlier, so Thomas's Collins wasn't necessarily original, but the name stuck and it became part of the canon of classic cocktails.

Deservedly so. It's a great drink—and also a model for how we should respond to disinformation. A century and a half later, we all recognize Tom Collins, thanks to Jerry Thomas. And thanks, also, to cocktail historian David Wondrich, whose research made Thomas a household name again.

SERVES ONE

* 2 ounces dry gin or Old Tom gin (see recipe note)
* ½ ounce fresh lemon juice
* ½ ounce simple syrup
* Club soda
* Lemon wedge, for garnish

Pour the gin, lemon juice, and simple syrup into a cocktail shaker with ice. Shake well and strain into an ice-filled collins glass. Top with club soda and garnish with a lemon wedge.

Recipe note: Old Tom gin is a slightly sweeter and less botanical-forward gin. Sometimes it's been aged and shows a little straw color, but not always.

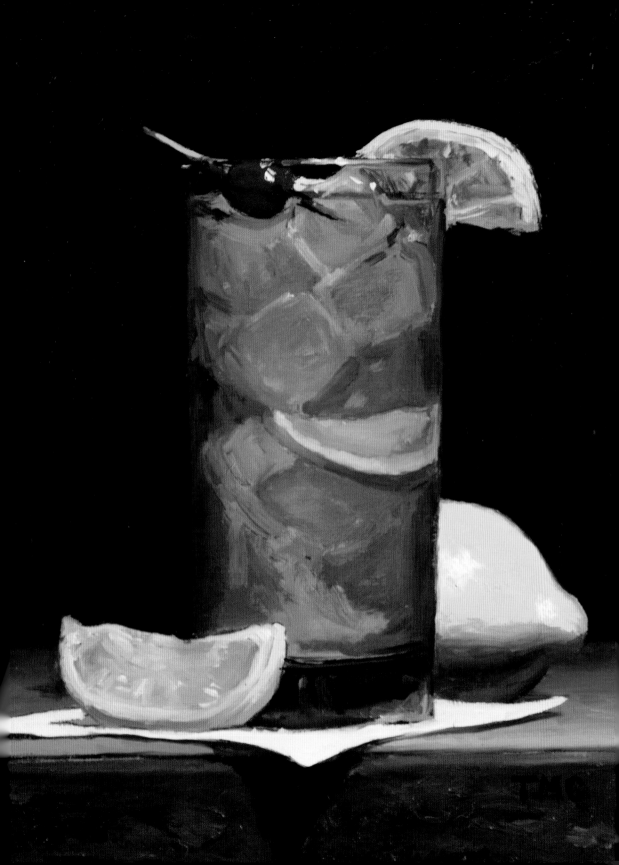

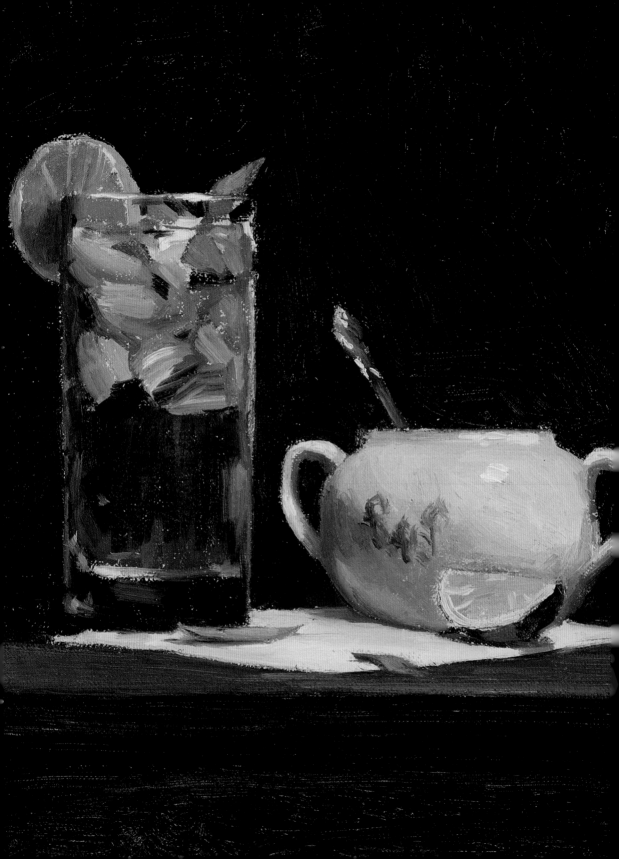

Mojito

The must-see bar on the Mojito tour of Havana is La Bodeguita del Medio, a small boîte in a slightly shabby neighborhood. Most days, the little bar's so full that patrons spill onto the street, all jockeying to glimpse the famous sign that for years has been offered as proof that Ernest Hemingway was a Mojito fan *and* that La Bodeguita made the best one. In handwriting that purports to be Hemingway's, it reads:

My mojito in La Bodeguita;
My daiquiri in El Floridita
—ERNEST HEMINGWAY

Although it's been hanging on the wall of the bar since the 1950s, it turns out the sign's a fake, albeit a pretty convincing one. The owners of La Bodeguita apparently cooked up this bit of early influencer marketing without any concern for the possibility that Hemingway may not even have liked Mojitos. There's no evidence he did, according to Hemingway biographer Philip Greene.

La Bodeguita still makes a pretty great drink, though. And it *was* a writer's bar, frequented back in the day by Pablo Neruda and Gabriel García Márquez, so it's still worth a visit by anyone with a penchant for literary haunts. Moreover, for those with a decent sense of irony, it's fun to witness countless tourists flocking to buy a drink at one of the few bars Hemingway *didn't* frequent.

SERVES ONE
* 8 or more large fresh mint leaves
* ¾ ounce simple syrup
* ½ lime
* 2 ounces light rum
* 3 ounces club soda
* Fresh mint sprig, for garnish

Muddle the mint leaves and simple syrup in a highball glass. Squeeze in the lime half and stir briefly. Fill the glass with crushed ice, pour in the rum, and then top with club soda. Garnish with a mint sprig.

Part Two

Aperitivo Hour

What we call "happy hour" looks pretty similar anywhere in the world where after-work drinking and snacking rituals are a thing, but world travelers hold Italy's *l'ora del aperitivo* in especially high esteem. Aperitivo hour is said to have started nearly two hundred years ago in the north of Italy, because the vermouth and bitter liqueurs the region produced were becoming so good it was decided citizens needed a special time of day dedicated to enjoying the local liquid bounty.

The word *aperitivo* is derived from *apero*, an Italian word that, simply enough, means "open." *L'ora del aperitivo* is when we start to open—bottles, for starters, but also our appetites, with the help of *cicchetti* (snacks). Most important, it's the time to open up your mind—and soul—to the possibilities the evening has to offer.

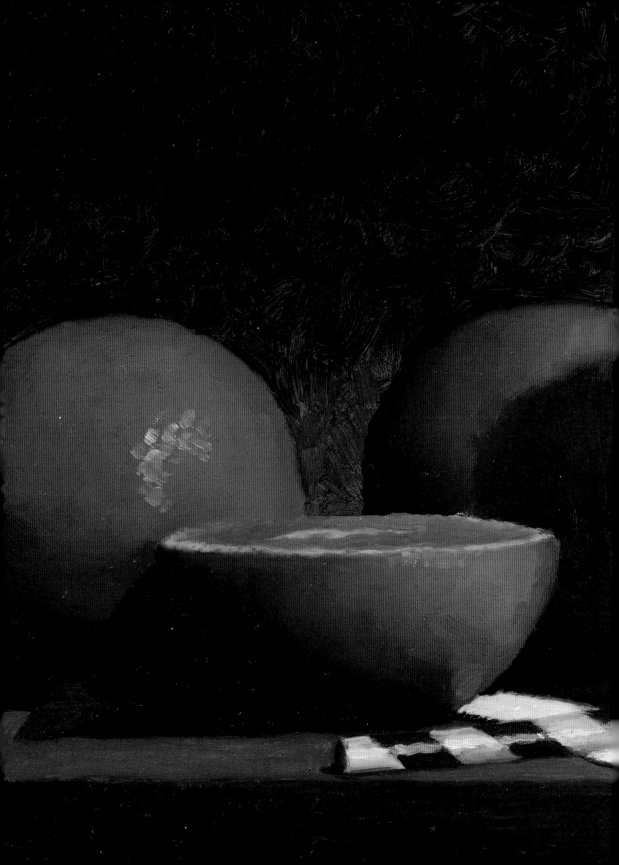

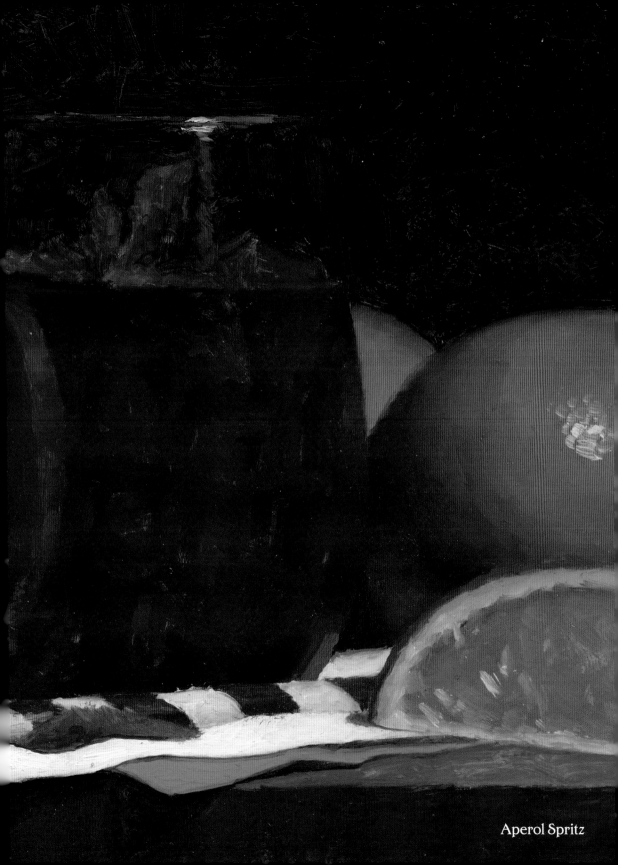

Aperol Spritz

Aperol Spritz

Pink and fizzy, the Aperol Spritz may look like a lightweight, but it's actually a powerhouse. Before about 2010, few people outside of Italy had ever even heard of Aperol, a hundred-year-old, relatively sweet and gentle *aperitivo* from Padua. Within a few years of being introduced to North America, though, it was practically a household name, all thanks to this spritz, which did all the heavy lifting in introducing this "new" liqueur to the rest of the world.

Actually, that was Act Two for the drink. Aperol had lingered in obscurity until the 1950s, when people around the Dalmatian Coast started adding a splash of it to their wine spritzers to boost the flavor, and the Spritz Veneziana was born. Although the history is fuzzy, we know the drink really hit the big time when it became mononymous and people just started referring to it as the Spritz—no modifier, no explanations. You know you've really made it when you can get away with using just one name.

SERVES ONE

* 2 ounces Aperol
* 3 ounces prosecco
* 1 ounce club soda
* Orange twist, for garnish

Carefully pour the Aperol, prosecco, and club soda—in that order—into a large, ice-filled wine or collins glass. Garnish with an orange twist.

The alcoholic beverage industry in nineteenth-century Italy was surprisingly ruthless. The background to the competition goes like this: Basically, all the bitter liqueurs we now use as cocktail modifiers or digestifs started out as medicines or nutritional supplements—the southern European version of patent medicines. Take Strega, for example. Made in a small town near Naples from saffron, fennel, juniper, mint, and sixty-some other herbs and spices, Strega developed a solid fan base of people who used it to cure an upset stomach (or maybe just to forget about it). As it grew in popularity, though, literally hundreds of bright yellow imitations flooded the market. In response, Strega had to redouble its branding efforts to keep its customers loyal, which it did by investing in beautiful posters to promote the "Witch" medicine as the original, most authentic, and best product on the market.

This is not an unusual story. Any winning formula was quickly copied so the only real recourse these medicine men had was to advertise. In North America, the patent medicine folks favored live theater at traveling carnivals and fairs. In Italy, the manufacturers turned to art. The unexpectedly beautiful legacy of this cutthroat scene are the thousands of gorgeous posters for Campari, Fernet-Branca, Cinzano, and others, including Strega—all of which remain delightful to visually drink in today.

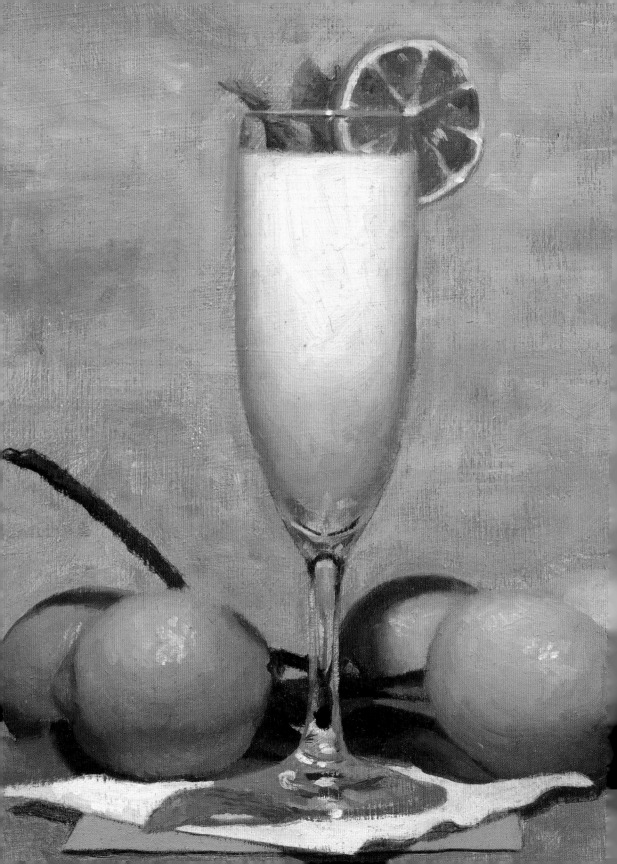

Sgroppino

Venice's Sgroppino is the most famous, but in other Italian cities and in Spain there are actually several different drinks that blend sorbet with booze. And, while they might sound like precursors to the mudslides and other ice cream drinks of the twentieth century, these southern European cocktails belong to an old tradition that blurs the distinction between alcohol and food.

Take zabaglione. Is it a dessert or a hearty Italian version of eggnog? The answer to that question is yes. And on top of that double duty, it also functions as breakfast *and* as a great way to warm yourself up on the ski slopes. It's all things to all people in the best possible way.

Sgroppino is the same but different since it's more a palate cleanser than a breakfast food. In some northern parts of Italy (up past the "butter line"), Sgroppino is spiked with vodka; in Venice, it's given an added layer of the region's famous prosecco, perfect for washing down the fatty meats and cheese you nibble on during happy hour. It's definitely not the most rarefied cocktail and it certainly isn't the height of the Italian wine culture, but it's easy-drinking fun and, to be sure, way better than a juice cleanse.

SERVES ONE

* 1 ounce vodka
* 3 ounces prosecco
* ½ cup lemon sorbet or granita
* Sprig of mint, for garnish
* Lemon wheel, for garnish

Place the vodka, prosecco, and sorbet in a blender and blend until smooth. Pour into a wineglass and garnish with the mint sprig and lemon wheel.

Americano

Even casual James Bond fans know of the Vesper cocktail that author Ian Fleming invented for 007 in his first novel, *Casino Royale* (see page 96). Living in the Vesper's shadow, however, is a *far* better drink ordered by the fictional spy earlier in that book: the Americano, the actual first Bond cocktail.

Maybe this light and refreshing Italian classic would have gotten more love if it went by its original name—the Milano-Torino. That's what it was called when it was created more than 150 years ago at Gaspare Campari's café in Milan when they mixed the house *aperitivo*, Campari, with a new aromatic wine, Vermouth di Torino. It's way more fun to say Milano-Torino *and* it would clear up a lot of confusion in Italian cafés, as anyone who ever ordered an Americano and wound up with a cup of coffee will tell you.

Regardless of the name, the world would be a better place, we're sure, if more people were in the habit of ordering this low-ABV (alcohol by volume) drink—one designed to put the spring back in your step after a long day wandering through galleries and ruins or, for that matter, toiling away at the office.

SERVES ONE

* 1½ ounces Campari
* 1½ ounces sweet vermouth
* Club soda
 (see recipe note)
* Orange twist,
 for garnish

Place ice in a large rocks glass. Pour in the Campari and vermouth. Stir and top with club soda. Garnish with an orange twist.

Recipe note: The original Milano-Torino cocktail didn't include club soda. An Americano can be made either way, but the sparkle of the modern version is lovely, especially at the end of a long, hot day.

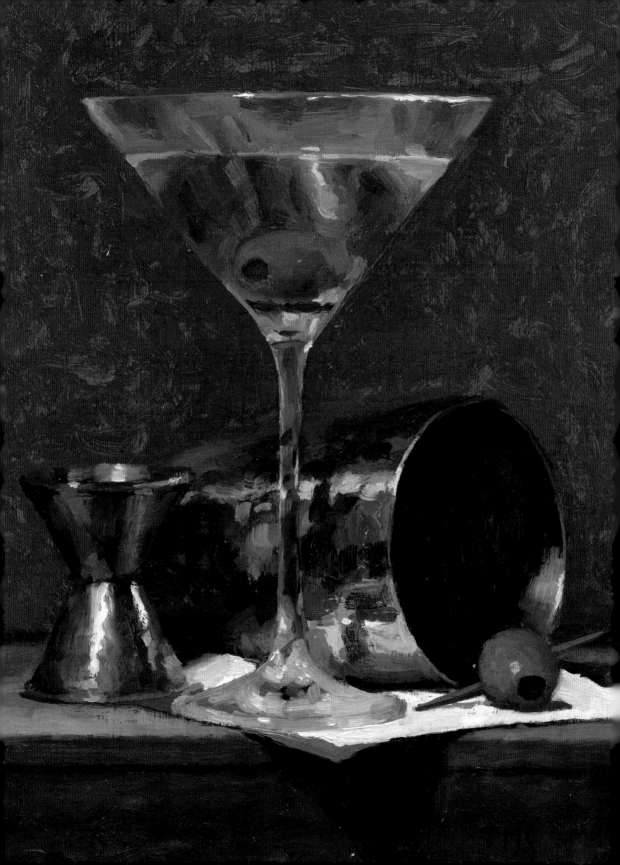

Martini (Classic Gin)

There's no debate about the ingredients in this drink—gin and dry vermouth. A Vodka Martini is a different animal altogether. There is, however, considerable disagreement as to the correct proportions.

Julia Child, for example, championed the Upside-Down Martini (five parts vermouth to one part gin), bucking the fashion, since at the time most people preferred their Martinis dusty dry, even joking that it was enough to merely *glance* in the direction of France rather than adding any actual vermouth. That conception began to lose its iron grip on Martini culture about twenty years ago, as cocktalians started becoming interested in vermouth—and, just as crucially, as bartenders learned to store vermouth in the refrigerator and not on the bar top, where it spoiled after only a few days.

This discovery that, when properly looked after, vermouth actually tastes great led to a renewed enthusiasm for "wetter" Martinis. Many cocktail experts advocated trying the old Prohibition-era, two-to-one formula (see the recipe below); some played around with 50-50, and those who really didn't like strong drinks in the afternoon opted for the "Reverse Martini" (two parts dry vermouth to one part gin). Julia, once again, was way ahead of the trends.

SERVES ONE

* 2 ounces dry gin
* 1 ounce dry vermouth
* Castelvetrano olives or lemon twist, for garnish

Combine liquid ingredients in a mixing glass and stir over ice until well chilled. Strain into a chilled cocktail glass and garnish with olives or a lemon twist.

Café Society

Although it's hard to imagine the time before dining out became a regular part of everyday life, the modern restaurant is a fairly recent invention, which only became a common feature in urban centers (particularly Paris) in the 1800s. For the first century of its existence, however, this novel form of entertainment was only accessible to the wealthy few and those who couldn't afford to eat out in style had to settle for the far less formal atmosphere of the cafés. Fortunately, the lively, more bohemian atmosphere of the open-air alternatives to restaurants was exceptionally attractive to artists, writers, and thinkers, and so "café society" quite organically became an important

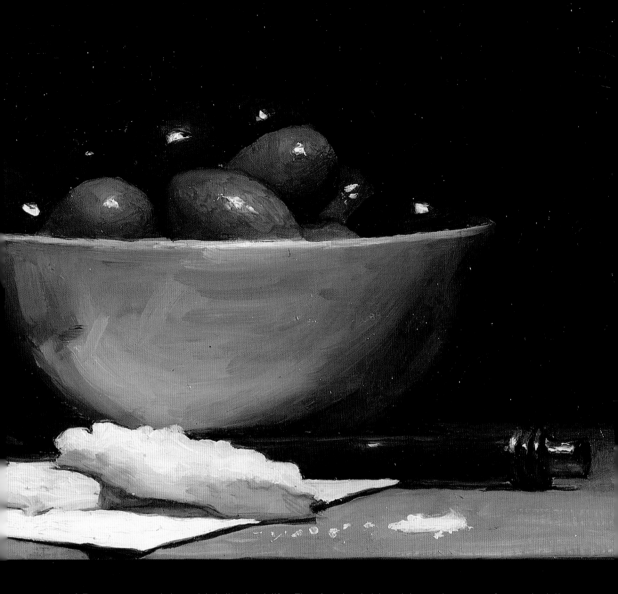

part of European social and intellectual life. The food might not have been as fancy, but the company was way more fun.

To Americans visiting Europe, café society represented one of the most defining differences between the United States and the Continent, since in America public social life was largely shuttered behind saloon doors. That changed, to some degree, after Prohibition's repeal, when some cities tried to mimic the Continental aesthetic with patios and promenades. Still, nothing really compares to the romance and history of taking a drink on the *terrasse* of one of those Left Bank institutions—Les Deux Magots, Café de Flore, and all the rest—that used to host the luminaries of café society.

Adonis

In the fall of 1884, Broadway was abuzz over *Adonis*, a burlesque musical that told the story of a ridiculously handsome statue that miraculously comes to life. Unlike Pinocchio and other inanimate-object characters who become animated and desperately cling to life, however, Adonis finds human beings insufferable and comes to the conclusion that he doesn't want anything to do with them—that he's better off made of marble.

Adonis the character may have returned to stone, but *Adonis* the musical had a long life: At 603 consecutive performances, it set the then-record for Broadway's longest-running show—an honor it retained for nearly a decade. When *Adonis* hit 500 performances, the Waldorf-Astoria decided to immortalize it with a namesake cocktail. This flawless, gorgeous drink is the perfect tribute, since it's a temperate drink that, unlike many of the potent, boozy drinks of the era, is built for endurance. Made from low-alcohol aperitif wines, it's the sort of cocktail that can be sipped and sipped but still allow you to stay sharp and perform, even with a long night—or run—ahead.

SERVES ONE

* 2 ounces fino or manzanilla sherry
* 1 ounce sweet vermouth
* 2 dashes Peychaud's or Angostura bitters
* Lemon twist, for garnish

Stir all liquid ingredients together over ice in a mixing glass. Strain into a chilled coupe or cocktail glass. Garnish with the lemon twist.

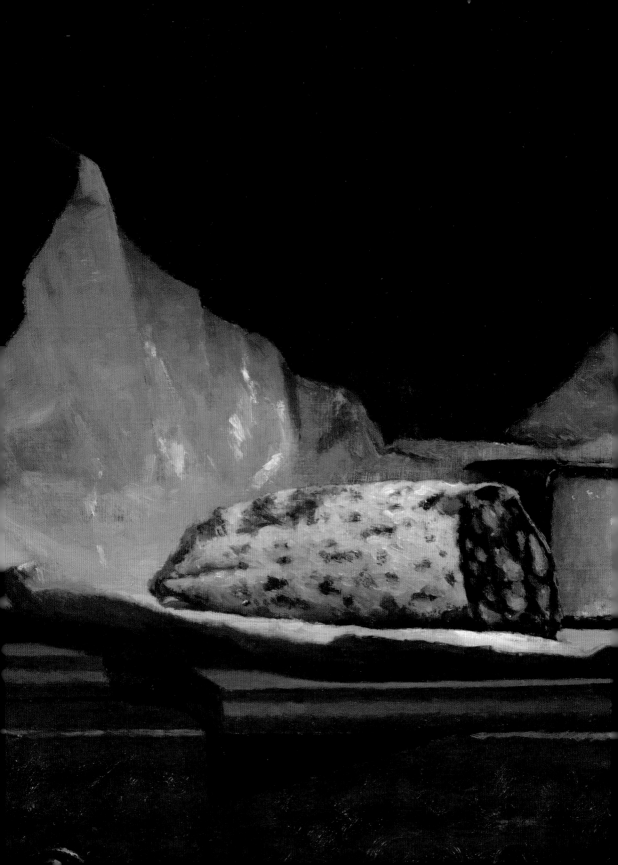

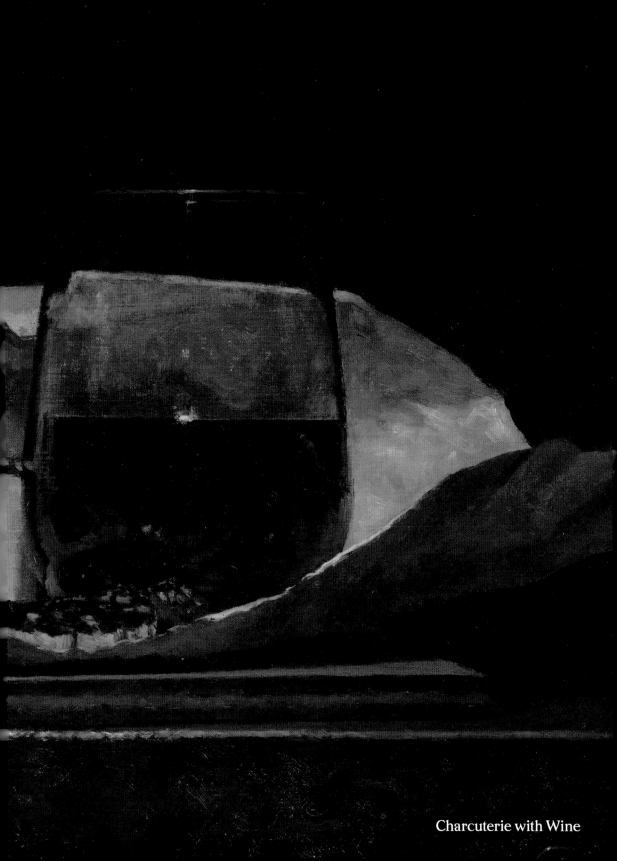

Charcuterie with Wine

Charcuterie with Wine

In some parts of the world, wine still *is* a food. Nobody would think of eating lunch, let alone dinner, without a glass of the local plonk.

As the saying goes, "What grows together goes together." For most of the rest of us, who aren't entirely sure what's grown where, there are wine pairings. This game can be somewhat intimidating, especially since there are no longer any hard-and-fast rules and today's sommeliers are a little more laissez-faire in their suggestions. Red wine with fish? Depending on the varietal, it could be brilliant. Turkey, perhaps surprisingly, goes perfectly with Pinot Noir. Lardo and Lambrusco? A natural fit. Thai food and Riesling go hand in hand. Even buttered popcorn has a perfect partner—Champagne.

But if you're unable to find, say, the perfect Finnish wine to pair with your reindeer meatballs, don't worry—just pick something you like. Wine, in general, goes really well with food, so it's hard to go too far afield. (Do note, however, that green salads are notoriously difficult to find appropriate wine partners for.)

Since we have neither space nor expertise enough to offer you an actual winemaking course, here's a recipe for one of our favorite wine-based cocktails.

New York Sour

SERVES ONE

* 2 ounces rye whiskey
* ¾ ounce fresh lemon juice
* ¾ ounce simple syrup
* ¾ ounce fruity red wine

Shake all ingredients except the wine over ice in a cocktail shaker. Strain into an ice-filled rocks glass and float the red wine on top.

Serving Temperatures for Wine

Whites in the fridge and reds on the rack, right? Well, not so fast. While it's true that white wines should be chilled and most reds should not, sommeliers the world over lament the fact that the vast majority of white wine is served too cold and red too warm. Each varietal or expression has an optimal serving temperature, starting with sparkling and ice wines, two of the few that can be served directly after being taken out of the refrigerator. Most other whites should be served a little warmer—some as high as 50°F.

Why? When a drink is too cold, its flavors are muted. If a wine is too sweet, you might want the sugar tamped down, so a very sweet sparkling wine might be more palatable at a cooler temperature. A fine, full-bodied white, like an Albariño or an oaked Chardonnay, on the other hand, will "open up" and reveal more complex flavors at a higher temperature. Best serving temps for rosé wines and very light young reds tend to start around the mid-fifties, then climb up to just under room temperature for heavier wines, such as Shiraz, Cabernet Sauvignon, or red Bordeaux.

Strawberry Daiquiri

The story of the Daiquiri usually goes like this: An American mining engineer working in Cuba just after the Spanish-American War ran out of gin and applied his problem-solving skills to drinks-making with the one liquor that's never in short supply in the Caribbean—rum.

There's one small problem with this story—namely, that the locals already had a rum, lime, and sweetener drink of their own, called the Canchanchara. So is the Daiquiri a case of cultural appropriation? It does smack of it. To be fair, though, the Daiquiri's stunning success *does* have a lot to do with the unique relationship that Cuba and the United States "enjoy."

Named by that American mining engineer after the Daiquirí mines he worked at, the drink was carried back to the United States as a trophy. Prohibition actually boosted the Daiquiri's popularity even higher, since it drove Americans to take alco-holidays in Havana, where some became barflies at El Floridita, aka *La Cuna del Daiquiri*. (*Cuna* means "cradle.") There, expat Ernest Hemingway improved the drink by encouraging bartender Constantino Ribalaigua Vert to cut down on the sugar and add more rum.

Finally, it was a truly American invention, the Hamilton-Beach kitchen blender, that made the now-ubiquitous frozen Daiquiri possible. It's the strawberry-flavored version of that drink that we feature here.

SERVES ONE

* 2 ounces white Cuban or Puerto Rican rum
* ¾ ounce rich simple syrup (two parts sugar to one part water)
* ¾ ounce fresh lime juice
* 5 fresh strawberries, hulled
* 1 cup crushed ice
* Lime wheel, for garnish

Place all ingredients except the lime wheel in a blender and blend on medium for 60 seconds, or until the drink has a smooth, even consistency. Pour into a tulip glass, garnish with a lime wheel, and serve with a biodegradable straw.

Cuba and Cocktails

One of the hardest antique cocktail books to get your hands on is *When It's Cocktail Time in Cuba*, written in 1928 by bon vivant and playwright Basil Woon. Thankfully, he recorded the lively scene in Prohibition-era Havana for posterity. Spoiler alert: It was essentially always cocktail time in Cuba in the 1920s, since the city took over mixology when most of North America decided to go dry. That was Havana's good fortune: It quickly became the hemisphere's cocktail capital—the Paris

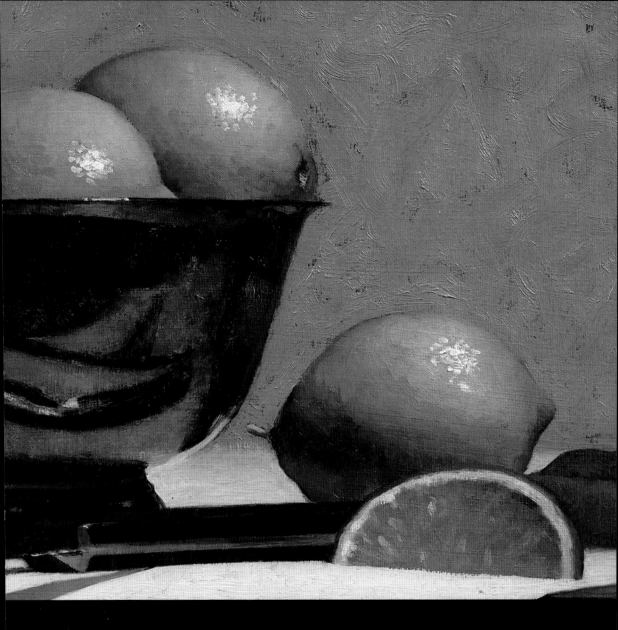

of the Caribbean. And it wasn't all Daiquiris and Cuba Libres, either. The golden age of Cuban cocktails saw the creation of the sturdy El Presidente, the fruity Mary Pickford, and the Adalor, a peach–and–sparkling wine drink that actually predated the Bellini.

Cocktail lovers owe a lot to Havana. It acted as a refuge for out-of-work American bartenders and a sanctuary for the cocktail itself. It kept the alcohol-dowsed torch lit while the flame went out in the United States, and for that we are eternally grateful.

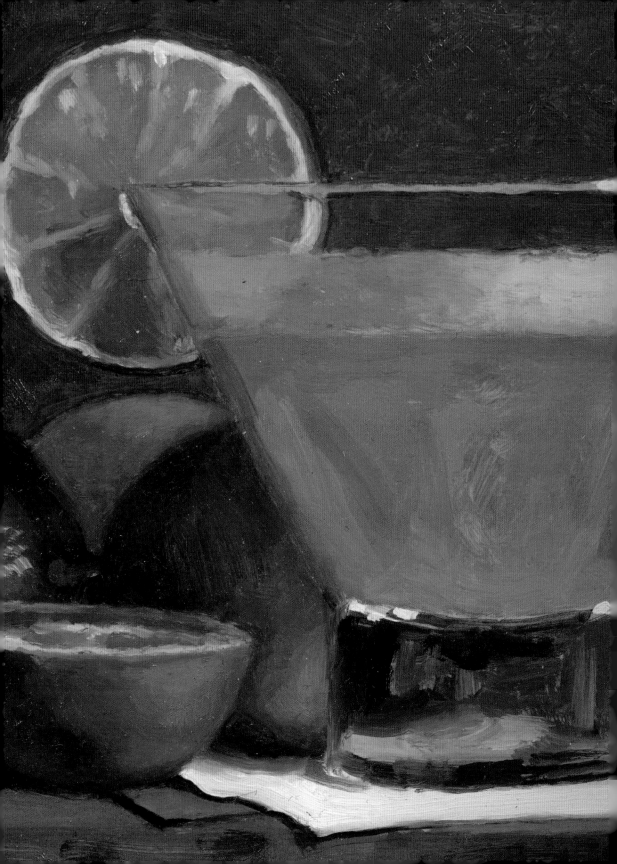

Pisco Sour

Long before every day was a hashtag holiday, Peru declared the first Saturday of every February National Pisco Sour Day. The first *Día Nacional del Pisco Sour* was celebrated in 2003, an early move in the country's campaign to establish pisco, an unoaked grape "brandy," as a distinctive part of Peru's culture and heritage.

Of course, there's the uncomfortable fact that neighboring Chile also claims pisco as its own. Peru's holiday isn't just branding, though. The Pisco Sour, arguably the king of all sours, is *genuinely* Peru's national cocktail, proudly made pretty well everywhere across this diverse country, from the rainforest to the Andes. There are variations (our favorite is the one infused with coca leaves), but they all build on the recipe perfected in the 1920s by Victor Vaughen Morris—nicknamed "Gringo"—a former florist from Utah who went to Peru to work on the railroads and ended up opening a saloon in Lima. His touch? Shaking up the usual pisco and lime drink with egg white so it would have a nice foamy top and garnishing it with a few drops of Angostura bitters.

SERVES ONE

* 2 ounces pisco
* 1 ounce fresh lime juice
* ¾ ounce simple syrup
* ½ egg white
* Tiniest pinch of salt
* Angostura bitters
* Lime wheel, for garnish

Place all ingredients except bitters in a cocktail shaker with ice. Shake well and strain into a chilled coupe or cocktail glass. Gently shake a few drops of bitters on the frothy top of the drink and garnish with a lime wheel.

Gin and Tonic

Although the Gin and Tonic was created by British soldiers in nineteenth-century India, over the past decade this standard, fairly straightforward refresher has been reimagined and given new life as the Gin-Tonic in the many "gin bars" of Spain and Portugal. These bars stock hundreds of different gin expressions and use them to build bespoke Gin-Tonics, seasoned with everything from pink peppercorns to fennel fronds to highlight and accentuate the spirit's botanicals. The somewhat elaborate creations are then presented in oversized wineglasses and snifters—unlike the highball or rocks glasses in which garden-variety G&Ts are usually served.

Such presentations are bound to confuse, perhaps even infuriate G&T purists, but not for long. It's easy to be won over by this "more is more" approach to the classic drink, designed to be sipped for ages as life unfolds in front of you on the plaza or the playa. (The recipe that follows is for the classic libation.)

SERVES ONE

* Lime or lemon wedge, for garnish
* 2 ounces dry or Plymouth gin
* Tonic water

Rim a highball glass (or, if you prefer a shorter drink, a rocks glass) with the lime wedge and fill with ice cubes. Pour in the gin, top with tonic water, and garnish with the lime wedge.

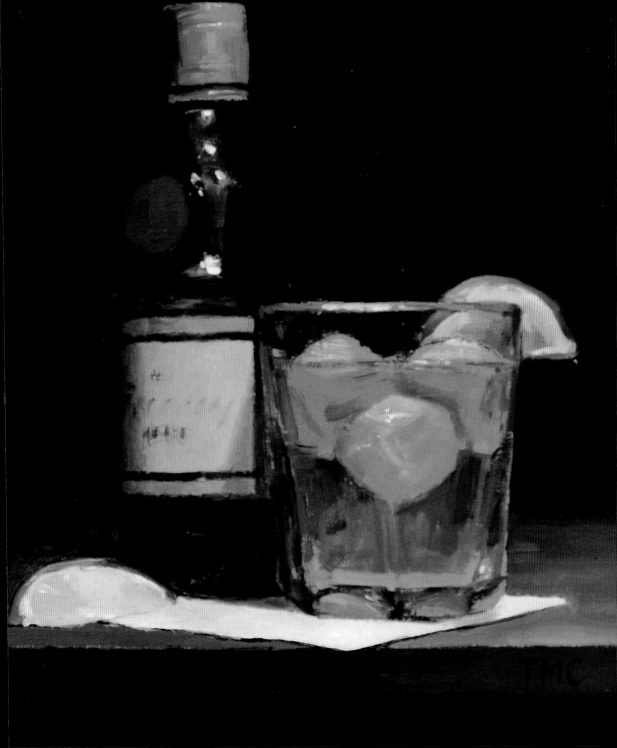

Moscow Mule

Casting one of her very best "I want to be evil" looks, singer Eartha Kitt brought her venomous elegance to one of Smirnoff's "Mule Party" magazine ads in the mid-1960s. It's one of our all-time favorite celebrity booze advertisements—a game Smirnoff caught onto faster than a lot of other liquor companies. The reason this vodka giant was so savvy about the value of celeb endorsements (what we now call "influencer marketing") probably has something to do with where the spirit got its big break—the Cock'n Bull on LA's Sunset Strip. And the vehicle that launched it was the Moscow Mule, which became phenomenally popular in the 1940s.

The drink's backstory isn't so glamorous: The Cock'n Bull's basement needed cleaning out, because it was full of cases of unpopular items, including ginger beer and Smirnoff vodka. (Americans didn't drink a lot of vodka back then.) A bartender decided to see if he could solve two problems with one drink and he began serving up Moscow Mules to the movie stars at the bar. To make sure nobody forgot its name, Smirnoff launched its "Mule Party" campaign, hiring a lot of then-famous-but-now-mostly-forgotten people like comedian Sid Caesar, actor Robert Morse, and orchestra leader Skitch Henderson—and, of course, the immortal, impossible-to-forget Eartha Kitt.

SERVES ONE

* 2 ounces vodka
* 1 ounce fresh lime juice
* 4 ounces ginger beer
* Lime wedge, for garnish

Build the cocktail in a copper mug. (A highball glass will do fine if you find that you're suddenly all out of copper mugs.) Start with ice, then add the vodka, lime juice, and ginger beer. Stir briefly and garnish with the lime wedge.

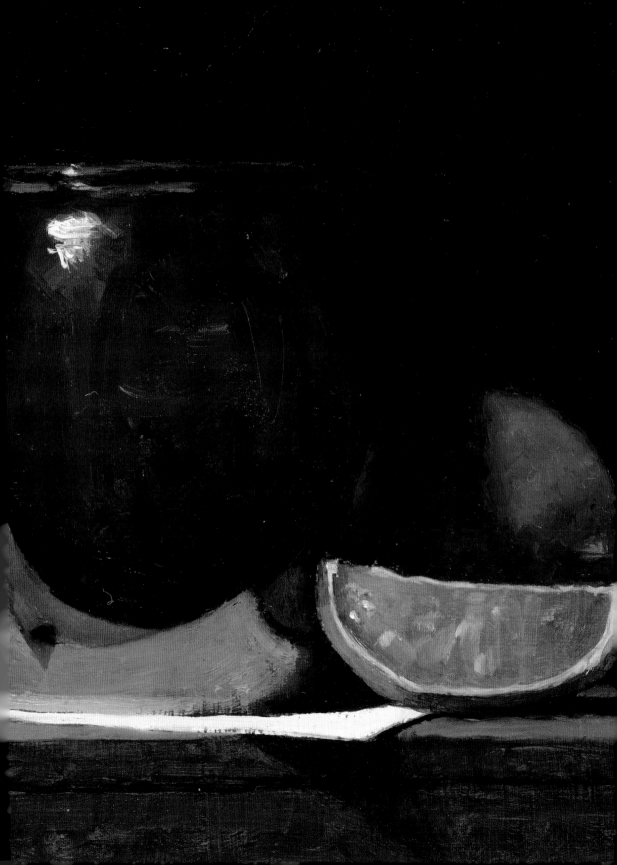

Absinthe Drip

A long time ago, happy hour used to be green. During la Belle Époque, *l'heure verte* (the green hour) saw the cafés of Paris fill up with artists, writers, and scenesters officially calling it a day with a glass or two of absinthe.

Originally a medicine created in Switzerland by the preposterously misnamed Dr. Ordinaire, absinthe rose to popularity in the second half of the nineteenth century, particularly in France, which at the time was experiencing a wine shortage thanks to the phylloxera louse, which loves to eat grapevines. Unfortunately, absinthe became too popular for its own good. As people got carried away with it, authorities began to believe (erroneously) that the drink was poisonous. If properly made, it wasn't. And it still isn't. But fake news does have a way of confusing people, and, before long, countries around the world started banning the drink. In 1915, even France fell in line and officially put an end to the "green hour."

It's often said that a lie gets halfway around the world before the truth can pull its pants on. We'd like to add that misinformation has remarkable staying power: Scientists started clearing absinthe's name in the 1990s, but a lot of people still think it has demonic powers.

SERVES ONE

* 2 ounces absinthe
* 1 sugar cube
 (see recipe note)
* 4 ounces ice-cold water

Pour the absinthe into a glass—preferably a Pontarlier absinthe glass with a reservoir at the bottom. (If you don't have an absinthe glass, any stemware will do.) Place an absinthe spoon across the top of the glass and put a sugar cube on top of the spoon. Very slowly pour the water over the sugar so that the syrup slowly drips through the slots in the spoon into the drink. As the sugar water mingles with the spirit, milky clouds—called the *louche*—will form in the drink. By the time you finish pouring the water, the absinthe should be opaque and opalescent with a hint of green.

Recipe note: There are two main types of absinthe—*verte* and *bleue*. People often skip the sugar with the latter, since it's typically a little lower-proof and needs less sweetener to punch back the alcohol.

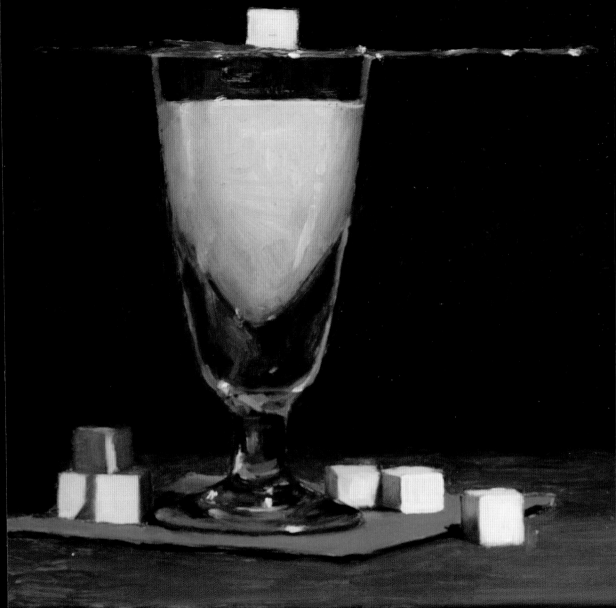

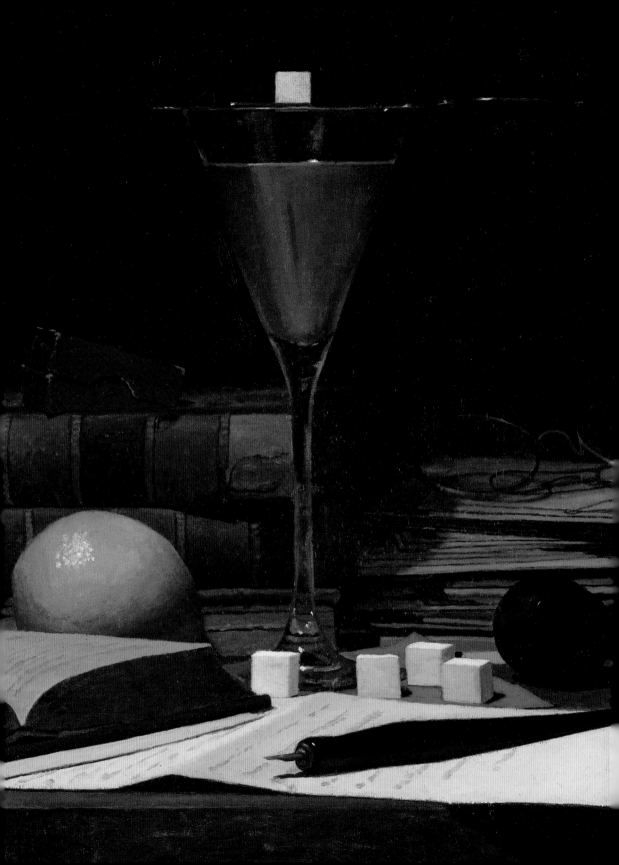

Absinthe and the Arts

The "green muse" was a seductive mistress of the arts, inspiring and ensnaring the likes of Édouard Manet, Edgar Degas, Pablo Picasso, and, most famously, Vincent van Gogh. And it wasn't only visual artists who fell under her spell. Oscar Wilde, Marcel Proust, and James Joyce were all absinthians, as was Charles Baudelaire, who, in "Poison," a poem from his scandalous *Flowers of Evil* collection, wrote this about absinthe: "None of which equals the poison welling up in your eyes that show me my poor soul reversed, my dreams throng to drink at those green distorting pools."

Because it exerted an outsize influence on the arts of la Belle Époque, absinthe has been a source of fascination for many poets, musicians, and artists ever since, all of whom want to learn the secrets of the green fairy. Is it a magic potion? A hallucinogen? A poison?

There's nothing particularly poisonous about absinthe, compared to other liquor, so we have to assume that its magical powers were divined by people who loved to watch the louche—the visual effect of bursts of liquid slowly clouding up the drink as water mingles and dances with the spirit. Watching absinthe turn milky is lovely, hypnotic, and evocative—and at least a little bit trippy.

Cocktail Party

Balls and banquets come with cumbersome rules and formalities. Tea parties are too twee. And while backyard barbecues, block parties, and garden get-togethers are great, they're relaxed affairs compared to a cocktail party, which has a certain cachet and unmatched energy.

Part of the cocktail party's appeal is that, even though the drinks should be very serious and made with the utmost care, the guests are under no obligation to take them too seriously. Smart, well-made cocktails are mainly the fuel of the party—not the center of attention. The focus ought to be on what really matters: the guests' outfits, their possibly questionable behavior, and, most interesting of all, the lively cocktail party chatter.

Bramble

Although it hasn't yet stood the test of time, the Bramble is what many bartenders call a "modern classic"—sort of the equivalent of an honorary doctorate in the cocktail world. What's truly remarkable about this cocktail, however, isn't that it hearkens back to the past but, rather, that it anticipated the future. Invented by Dick Bradsell at Fred's Bar in Soho, London, in 1984—a quarter-century before sharing photos of food and drink on social media became a thing—the Bramble was a proper spectacle and a delightful conversation starter.

It's not just that the Bramble is beautiful, it's that it slowly changes color for the first minute of its life, as the deep purple crème de mure slowly trickles down through the crushed ice to fulfill its destiny as a pink drink. It's highly Instagrammable. Even if they didn't have the word for it back in 1984.

SERVES ONE

* 1½ cups crushed ice, divided (crucial to achieving the visual effect)
* 2 ounces gin
* 1 ounce fresh lemon juice
* ¾ ounce simple syrup
* ¾ ounce crème de mure or blackberry liqueur (if unavailable, use crème de cassis or Chambord)
* Mint sprig, for garnish
* Lemon half-wheel, for garnish

Fill a rocks glass with 1 cup of crushed ice and set aside. Then fill a shaker with ice cubes (not crushed ice) and add the gin, lemon juice, and simple syrup. Shake well and strain into the glass over the crushed ice. Add the remaining half-cup of crushed ice, mounding it above the rim of the glass, and then slowly drizzle the crème de mure on top so that it seeps into the drink. Garnish with the sprig of mint and a lemon half-wheel.

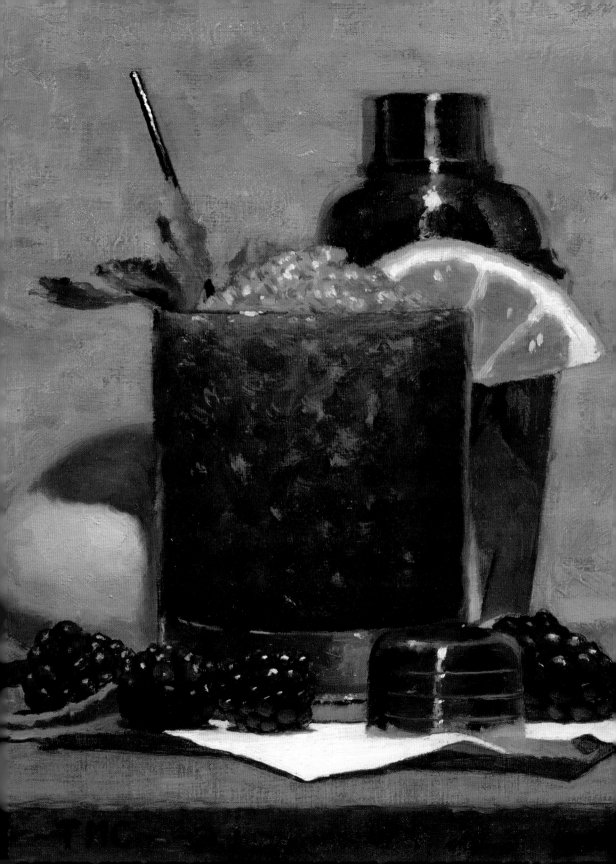

Gin and Sin

When gin's closest ancestor, jenever, was first being distilled in the Netherlands some five hundred years ago, it was sold as a medicine—good for gout, joint pain, kidney problems, and basically anything that ailed you. Fast-forward two hundred years and the spirit had made its way over to England and degenerated from a cure-all to the scourge of society. During the eighteenth-century gin craze, everything from fallen women to urban poverty and civil disobedience was blamed on gin.

What changed? A big part of the problem was simply that the average Brit was used to drinking ale and didn't really understand how much stronger gin was, ounce by ounce. It didn't help that gin, now being produced domestically in London's many "gin palaces," was cheap, so it was easy to get yourself into trouble quickly. It took a multipronged effort of anti-gin awareness campaigns, taxation, and legislation to get the situation under control, but gin would continue to be associated with sin for centuries after. And it would take until 2009 for London to amend its laws to allow a distillery to fire up a copper pot still and make gin in the city again—for the first time since 1820.

Hanky Panky

The famous bartenders of days gone by mostly had one thing in common—they were men. Bartending wasn't always a male domain, however. Brewing and distilling used to belong to the domestic sphere and many tavern-keepers and publicans of, say, three or four centuries ago would have been women. It wasn't until the 1800s that public drinking establishments started shutting most women out.

There is, however, one stunning exception: Ada Coleman, who in 1903 rose to become head bartender at the Savoy Hotel's American Bar in London, England, holding the position until 1925. Her most famous contribution to the cocktail canon is the Hanky Panky, which she said she invented for Sir Charles Hawtrey, a famous British comedic actor. (Oldsters may recall John Lennon babbling Hawtrey's name in "Two of Us," the first song on the Beatles' album, *Let It Be*.)

Coleman apparently created the drink when Hawtrey, after a hard day's work, walked into the Savoy and asked "Coley" for something with a bit of "punch." Draining the glass, Hawtrey declared, "By Jove! That is the real hanky-panky." We think so, too.

SERVES ONE

* 1½ ounces gin
* 1½ ounces sweet vermouth
* 2 dashes Fernet-Branca
* Orange twist, for garnish

Pour all the liquid ingredients into an ice-filled mixing glass and stir until chilled. Strain into a chilled coupe or cocktail glass and garnish with the orange twist.

Long Island Iced Tea

In the 1950s, long before the Long Island Iced Tea was even invented, bartenders had a special name for attention-seeking drinks like this one: "freak drinks."

What makes the Long Island Iced Tea freaky? For starters, there's its use of vodka, which mid-century bartenders still viewed with suspicion. By the time the drink was invented, though—allegedly for a 1972 cocktail competition at Long Island's Oak Beach Inn—the mere use of vodka wouldn't have qualified it for the "freak" canon. Creator Bob "Rosebud" Butt made his competition entry stand out by mixing the vodka with four other white spirits: tequila, gin, rum, and triple sec. There's no record as to who actually won the contest that day (possibly because the judges spent it drinking five-ounce cocktails). What we do know is that Butt's bizarre simulacrum went on to conquer the world.

Quite a few bartenders today have modernized this 1980s icon by making it over into a way-less-boozy sour. Such variations can be delicious. We think, though, that they hardly resemble the Long Island Iced Tea we recall from the good old days of big hair and spandex. Rosebud would, we're sure, agree.

SERVES ONE

* Lemon wedge
* ½ ounce vodka
* ½ ounce gin
* ½ ounce light rum
* ½ ounce tequila
* ½ ounce triple sec
 or Cointreau
* ½ ounce fresh
 lemon juice
* Cola
* Lemon wheel,
 for garnish

Rim a collins glass with the lemon wedge and fill the glass with ice cubes. Combine the vodka, gin, rum, tequila, triple sec or Cointreau, and lemon juice in a cocktail shaker with ice. Shake well and strain into the glass. Top with the cola and garnish with the lemon wheel.

Jack Rose

The Jack Rose might just be the best little cocktail nobody ever drinks. It's enough to make you wonder if there's some kind of curse on the drink, like those the Cubs and Red Sox once suffered through.

It got off to a fine start circa 1900 when it was popular at the Wall Street bar where it was invented. Then, out of nowhere, a Jersey City bartender tried to claim the Jack Rose as his own, casting confusion upon the drink's cultural identity. But the Jack Rose is definitely a New Yorker, even if it's made with New Jersey's applejack spirit.

We don't have an interesting story about how the cocktail got its name, but "Jack Rose" is a pretty obvious moniker for a pink drink made with applejack so we're going with that simple (if unverifiable) explanation. Later, the drink's name was dragged through the mud when it became—entirely coincidentally—associated with Bald Jack Rose, a gangster involved in a sensational murder. Even though the drink predated Baldy's reign of terror, the name itself caused the Jack Rose's popularity to slump. Then Prohibition delivered another blow by making applejack—the drink's defining ingredient—illegal.

Will the curse ever be lifted? We think so. Eventually, people have got to realize how delicious the Jack Rose is. After all, curses are made to be broken.

SERVES ONE

* 2½ ounces applejack
* ½ ounce fresh lemon juice
* ¼ ounce grenadine
* Lemon twist, for garnish

Fill a cocktail shaker with ice and add all the ingredients. Shake well and strain into a chilled coupe or cocktail glass. Garnish with a lemon twist.

Applejack

Before whiskey, there was applejack. Although bourbon is often considered "America's spirit," the first homegrown liquor made from all-American ingredients was applejack. It was first created on the Jersey shore in 1698 by Scottish immigrant William Laird. Also known as "Jersey lightning," the spirit used local apples, which were fermented and turned into cider and then, unlike most spirits, frozen instead of heated in a still.

The process is known as "jacking" (hence the liquor's name), and it follows the basic principle of distillation, except in reverse. Distillation is about separating out the ethyl alcohol from

the rest of a liquid by exposing it to an extreme temperature. (Conveniently, alcohol changes states—from solid to liquid to gas—at different temperatures than water.) Generally speaking, the distilling temperature is hot. But cold works, too, because alcohol doesn't just evaporate at a lower temperature than water; it also freezes at a much lower temperature than water. So, if you freeze hard cider and then discard the ice, the leftover liquid is a concentrated alcoholic product. Unfortunately, at this stage of the process it's also full of a lot of things that are less desirable—in particular, methanol, which is a potent poison. That's why you should definitely never try this at home. Even if you live on the Jersey shore.

Vieux Carré

Long before the revolving rooftop restaurant craze, there were merry-go-round bars. A surprising number of them, in fact, entertained guests in some of the best hotels across America, including the Copley Plaza in Boston, the Ritz-Carlton in Atlantic City, and, at the top of Chicago's Morrison Hotel, the Great Carousel in the Sky.

One of the very few merry-go-round bars that's still making the rounds is the Hotel Monteleone's Carousel Bar in New Orleans. It should be on every bar lover's bucket list. And when you finally do have the pleasure of hopping onto that revolving bar, be sure to order the Vieux Carré, a spectacularly sturdy and respectable drink (especially for the French Quarter, after which it was named). The drink was actually invented at the Monteleone—albeit in 1938, before the Carousel was installed.

It's the right drink to order at the merry-go-round bar. Or just about any bar, for that matter. This complex, boozy-herbal drink is New Orleans's answer to the Manhattan—and all the other boroughs' drinks as well.

SERVES ONE

* 1 ounce rye whiskey
* 1 ounce cognac
* 1 ounce sweet vermouth
* ¼ ounce Benedictine
* 2 dashes Peychaud's bitters

Fill a mixing glass with ice cubes and add all the ingredients. Stir until chilled and strain into an ice-filled rocks glass.

Aviation

When the Aviation cocktail was invented by Manhattan bartender Hugo Ensslin, roughly around 1910, the Wright brothers' experiments were still practically current affairs. Flying was in the realm of fantasy for all but a few adventure-seekers and engineers, but that didn't stop people from getting excited that things were looking up. It was the great age of the skyscraper and you could get a sense of what it was like to travel up into the sky simply by taking an elevator to the top of, say, Times Square One, the 25-story building that was almost directly across from the Wallick Hotel (now razed), where Ensslin tended bar.

Although Ensslin didn't make a lot of notes in his 1917 *Recipes for Mixed Drinks*, which contains the recipe for the Aviation, it's often said that his light purple drink was his homage to the view of the horizon as seen from above. It's meant to evoke a lavender-tinged sky and the very idea that, even after a hard day, it's possible to rise above the fray and get a fresh perspective. What a lovely thought.

SERVES ONE

* 2 ounces gin
* ¼ ounce maraschino liqueur
* ¼ ounce crème de violette
* ¾ ounce fresh lemon juice
* Amarena cherry, for garnish

Shake all liquid ingredients in an ice-filled shaker. Strain into a chilled coupe or cocktail glass. Garnish with the cherry.

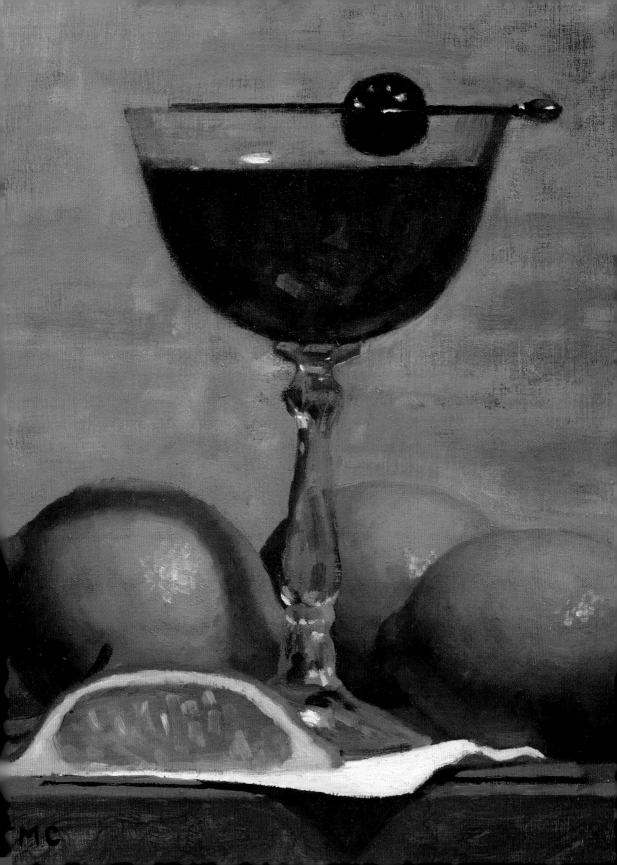

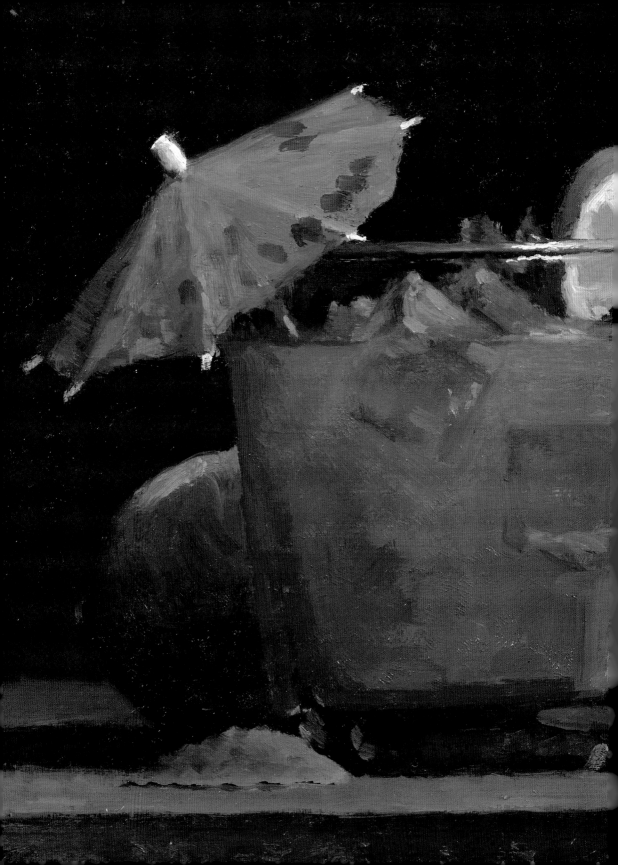

Mai Tai

The cocktail that launched a thousand cruise ships—not to mention tiki bars—is sadly misunderstood. The *only* juice in this mid-century rum-forward tiki staple is lime. No matter what Jamie Oliver or the bartender at TGI Fridays tells you, there's no orange, pineapple, or grenadine involved.

There's no excuse for bungling the cocktail now, given that anyone can Google the drink and find the correct recipe. Improbably, it was the Mai Tai's creator, Victor Bergeron (the founder of the Trader Vic's chain of tiki bars), who was at least partly to blame for the first wave of too-juicy Mai Tais. How so? Because Trader Vic refused to share his (excellent) recipe. Not long after it was invented in 1944, the Mai Tai grew so popular it became a "call drink"—meaning that customers would ask for it even when it wasn't on the menu. So bartenders around the world had little choice but to invent their own versions to satisfy those swept up in the Mai Tai craze.

Other than the Zombie, no cocktail defines and represents tiki culture better than the Mai Tai. But the secret to its success is the original Bergeron formula, which we know thanks to the tireless efforts of tiki expert Jeff "Beachbum" Berry.

SERVES ONE

* 1 ounce dark Jamaican rum
* 1 ounce light rum
* 1 ounce fresh lime juice
* ½ ounce orange Curaçao
* ½ ounce orgeat syrup
* ¼ ounce simple syrup
* Sprig of mint, for garnish
* Lime wheel, for garnish

Combine all ingredients (except the mint) in a shaker with ice. Shake well. Fill a rocks glass with crushed ice or ice cubes and strain the drink into the glass. Garnish with the mint sprig and lime wheel.

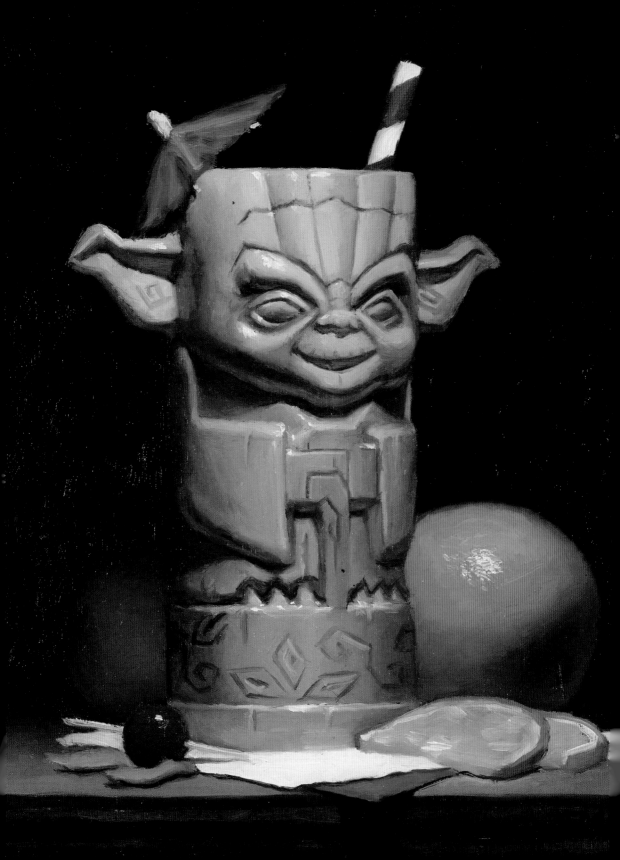

The Cocktail Parasol

We don't have a lot of answers when it comes to the cocktail parasol. Nobody is sure who first used it, or when, or even where the first paper parasol landed in a cocktail. Nor do we know which joker was the first to spread the (false) rumor that this flimsy object insulated the drink and kept the ice from melting too quickly. The parasol serves one function—to remind the *drink* that it is on vacation.

This isn't an ordinary scotch and soda, hanging out at the bar to talk shop after work or meet new friends and hook up. This is a drink on its day off, enjoying the music and dimly lit atmosphere without a care in the world, which is why you meet it at a Beachcomber Bar or Trader Vic's or the absolutely over-the-top Tonga Room & Hurricane Bar at the Fairmont San Francisco Hotel. These bars offer more than a drink and a scene. Like the merry-go-round bars that came before them, they offer an experience, an escape.

They're the Fantasy Island of bars or, as people now call them, our "happy places." And just in case you lose sight of the thatched bar or tune out Martin Denny's "Quiet Village" and start letting the anxiety of the modern world creep back in, the umbrella is there, right in front of you, to remind you of where you are. So be here now. The parasol isn't there to protect the ice. It's there to protect you—from the real world.

Manhattan

We love it when a cocktail has a real sense of place, like the Manhattan. It's far from the only drink to take its name from a city—there's the Singapore Sling, the Chicago Fizz, and the London Fog, to name a few. But New York is one of very few places to have several eponymous cocktails, including the five named after its boroughs—the Manhattan, the Bronx, the Queens, the Brooklyn, and, of course, the Staten Island Ferry, which is made with Malibu Rum and pineapple juice, as befits the tropical island getaway on the south side of New York Harbor.

Nobody really knows when the first Manhattan was stirred or who decided it should be the city's namesake mixed drink. (The oft-told tale about its being created at New York's Manhattan Club on the order of Winston Churchill's mother, Jennie, turns out to be bunkum.) But despite its lack of pedigree, cocktail historian Philip Greene has called the Manhattan the "first modern cocktail," since it would inspire so many other minimalist three- and four-ingredient drinks. Plus, it's the kind of drink that could be casually held in one hand (cigarette holder in the other) as you chatted away at a bar or cocktail party—precisely what the modern era called for.

SERVES ONE

* 2 ounces rye whiskey
* ¾ ounce sweet vermouth
* 2 dashes Angostura bitters
* 1 dash orange bitters
* Maraschino cherry (preferably the Luxardo brand), for garnish

Pour all the liquid ingredients into a mixing glass with ice. Stir and strain into a chilled coupe or cocktail glass and garnish with the cherry.

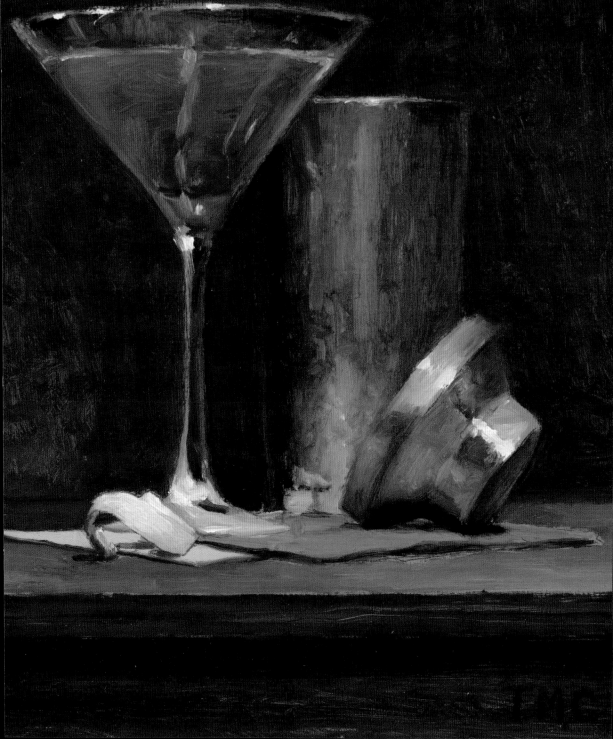

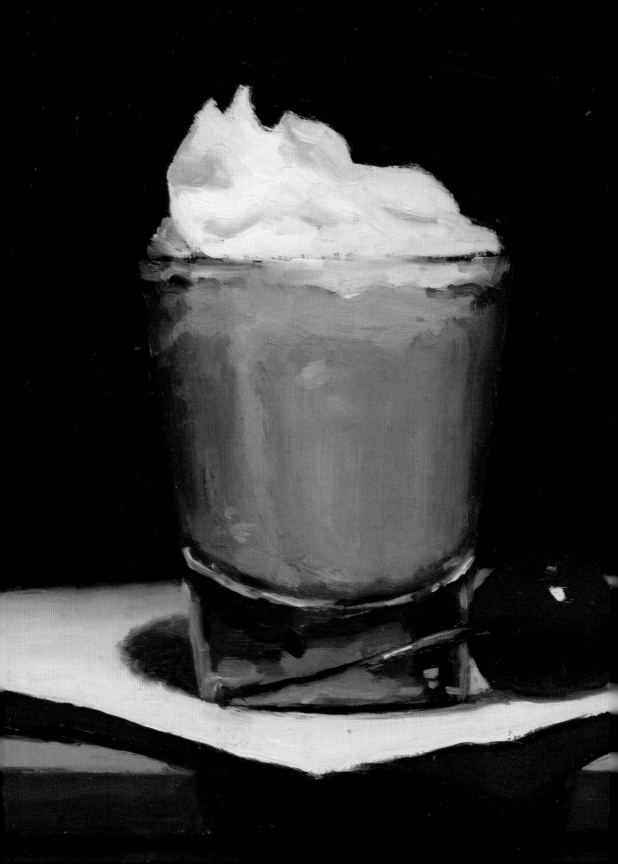

Explained

Even though its technicolor scarlet is a big part of the maraschino cherry's appeal, it's also a cause for concern. The hue is reminiscent of those practically fluorescent frogs whose brightly colored skin is a warning to predators—eat me at your own risk. Nature does have its ways of warning us, but for decades people threw caution to the wind and mindlessly ate whatever was in the glass once the Manhattan had been drained.

We won't go into the specifics of how the American maraschino cherry is made (the information is easy enough to find online), but we *will* say that it's a poor imitation of the Italian maraschinos that inspired it. These famed Marasca cherries, preserved in liqueur and imported from Italy and Croatia's shared Dalmatian Coast, were so cherished in the late 1800s that they found their way into drinks.

Prohibition is often blamed for the end of the good Italian cherries, which, as legend has it, were banned for their alcoholic content, but it's more likely that the invention of the Day-Glo American maraschino was just a cost-cutting measure since imported cherries were expensive. And since there was no shortage of American cherries, it made sense to make them at home, using a brining process that kept the cherries crisp, thereby "improving" on the garnish.

The end result? Proof that we don't always get better living through chemistry. We highly recommend upgrading to imported Italian cherries, be they Amarena cherries from Bologna or the original Luxardo Marasca cherries, packed in cherry juice and syrup in Padua. They cost a fair bit more, but the flavor difference is night and day and a jar seems to last forever. We've come around to thinking that cheap cherries are a false economy.

Cosmopolitan

The Cosmo essentially defined cocktail culture in the late 1990s, partly because the drink was featured so often in the hit TV show *Sex and the City* that it practically became the fifth main character. Even before that, though, this pink drink was a hit in several East Coast cities, including its birthplace, New York—but also Provincetown, Massachusetts, where it was taken up with such enthusiasm it might as well have been the Cape Cod resort town's official drink. It spawned countless imitators as bartenders designed "Martini menus" with dozens of signature cocktails, all mimicking the Cosmo's winning formula—vodka, fruit juice, and a snappy liqueur.

Few if any of those drinks, however, had the staying power of the Cosmo. Granted, as the craft cocktail trend leveled the so-called Martini bars, the Cosmopolitan was taken down a few notches. Carrie Bradshaw, for example, stopped drinking them, as we learned in the *Sex and the City 2* movie. When Samantha Jones asks, "Why did we ever stop drinking these?" Carrie responds, " 'Cause everyone else started."

That's a terrible reason if we've ever heard one to give up a perfectly tasty modern classic.

SERVES ONE

* Lime wedge
* 1½ ounces lemon vodka
* ¾ ounce Cointreau
* ¾ ounce cranberry juice
* ¾ ounce fresh lime juice

Rim a chilled cocktail glass with the lime wedge. Combine all the other ingredients in a cocktail shaker with ice. Shake well and strain into the glass. Garnish with the lime wedge.

Vesper

There's a simple rule for when to shake and when to stir—if the recipe calls for eggs, cream, or juice, shake it. By contrast, clear drinks made with straight spirits (including aperitifs) are meant to be stirred.

So, how did James Bond get that whole Vodka Martini thing so wrong? Probably because he's not really a cocktail expert—007's expertise lies elsewhere. Still, many home bartenders defer to Bond when it comes to a number of drinks-related issues, including the notion that a Vesper, as Ian Fleming described it in *Casino Royale*, is a great drink that deserves to be on cocktail menus everywhere.

The truth is that, although the Vesper is a pretty little drink with a great story—not many drinks exist in fiction before appearing in real life—it's a little off-balance. To be fair, this may be because Kina Lillet was discontinued some years ago (see recipe note, page 5). Since the drink has a way of staying alive, our suggestion is to salvage it by tweaking the recipe slightly, as follows.

SERVES ONE

* 1½ ounces gin
* 1½ ounces Lillet Blanc
* ½ ounce Suze gentian liqueur
* Lemon twist, for garnish

Pour all the ingredients into a mixing glass with ice. Stir and strain into a chilled coupe or cocktail glass. Garnish with a lemon twist.

Paloma

When you order a Paloma in most bars in Mexico, you're likely to get tequila, a splash of lime, and Squirt or some other grapefruit soda. Although not exactly rarefied, the drink hits the spot. If, however, you order the drink in a trendy bar in Mexico City's La Condesa or Roma neighborhoods, the chances are pretty good you'll get a fancier version, with a little fresh grapefruit juice and maybe even a splash of mezcal. Although it's arguably tastier, it's way less "authentic." Why? Because, as far as anyone can tell, this drink of unknown origin wasn't invented until at least 1955—after Squirt became available in Mexico.

As for the drink's name, one popular though highly doubtful theory suggests that the drink is named after the nineteenth-century Spanish folk song "La Paloma" ("The Dove"). But since we're making things up, why not claim it was named for the 1954 Mexican folk song "Cucurrucucú Paloma" ("Coo-coo, Dove")? It's easier to make that case, since this wildly popular, highly dramatic song about lovesickness has been recorded by just about everybody, from Harry Belafonte to Joan Baez to Caetano Veloso and, around the time people started spiking grapefruit soda with spirits like tequila, would still have been incredibly popular in cantinas. It's pretty much the ultimate song to sing along with at mariachi hour, especially after a few Palomas.

SERVES ONE

* 2 ounces tequila blanco
* 2 ounces fresh grapefruit juice
* ½ ounce fresh lime juice
* ¼ ounce agave syrup (see recipe note)
* Salt, for rimming glass
* Lime wheel, for garnish

Fill a cocktail shaker with ice and add the liquid ingredients. Shake well and strain into an ice-filled, salt-rimmed rocks glass. Garnish with the lime wheel.

Recipe note: If the grapefruit juice is sweet (which it often is), you may wish to skip the sweetener. It can also be lightened up with the optional addition of an ounce or two of club soda.

Dirty Martini

Olive or twist? Not even a choice for some people, for whom the whole point of a Martini is to feast on some gin-soaked olives after finishing the drink. That practice evolved into the Dirty Martini (in which a splash of olive brine is added), then progressed to the filthy version, which can be as much brine as booze. Not every bartender approves, since the spirit is obscured by the salt, but most will humor it because the customer is supposedly always right. Probably even more important: Giving them their salt fix in the glass helps keep patrons from grazing at the bartender's garnish tray—pretty much the rudest thing you can do at a bar.

SERVES ONE

* 3 ounces gin (or vodka)
* 1 ounce olive brine from the jar (more if desired)
* ½ ounce dry vermouth
* Castelvetrano olives, for garnish

Fill a mixing glass with ice and pour in the gin (or vodka), olive brine, and vermouth. Stir until chilled and strain into a chilled cocktail glass. Garnish with three or more olives.

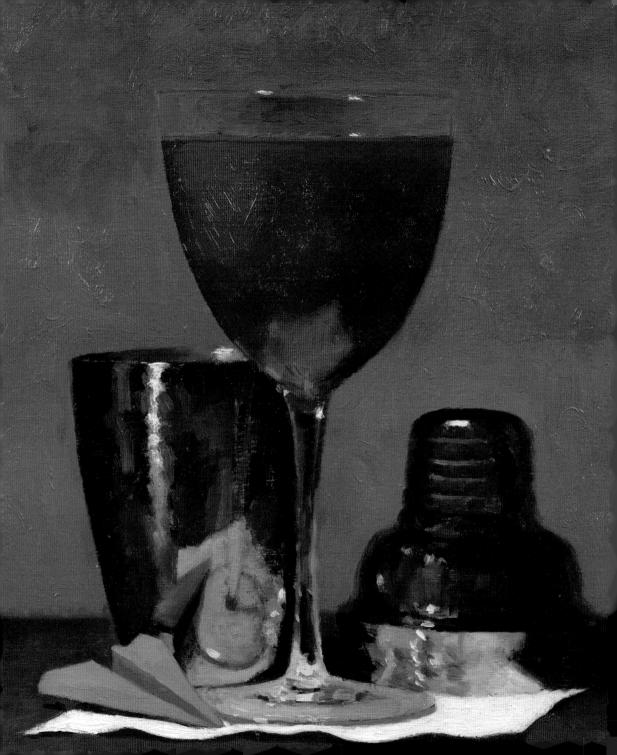

Paper Plane

The Paper Plane isn't nearly as controversial as the M.I.A. song "Paper Planes," which it was named after and which uses biting satire to make a point about stereotypes, prejudice, and systemic inequality. It's got a catchy tune, but if you listen closely you realize it's a lot angrier than it initially sounds, even sampling the Clash's angriest song ever, "Straight to Hell." The cocktail, by contrast, is easy-drinking and straight-up delicious.

The Paper Plane was invented at Milk & Honey, the speakeasy-style bar on New York City's Lower East Side that made pre-Prohibition drinks, hidden entrances, and jazz playlists so popular. We don't have a lot of insight into how the drink got associated with the song, except that Milk & Honey's owner, the late Sasha Petraske, had a soft spot for M.I.A., which he considered a guilty pleasure.

Like the song, the drink was an immediate hit and, before long, was inducted into the canon of "modern classics"—drinks that are so widely recognized that you can order one almost as easily as a Manhattan. Even outside of Manhattan.

SERVES ONE

* 1½ ounces bourbon
* 1½ ounces Aperol
* 1½ ounces Amaro Nonino
* 1½ ounces fresh lemon juice

Fill a cocktail shaker with ice and add all the ingredients. Shake well and strain into a chilled coupe or cocktail glass.

Zombie

Presumably a lot of cocktails were invented in the United States in 1934, the year after Prohibition was repealed. None, however, were as successful and long-lived as the Zombie, invented by Donn Beach (né Ernest Raymond Beaumont Gantt), founder of Don the Beachcomber, the Hollywood bar that started the tiki craze. (Eagle-eyed readers should note that the difference in spelling between Donn and Don is, weirdly, correct.)

Tiki was an exercise in excess, in reaction to the previous fifteen years, which had been an exercise in moderation and/or downright abstinence—at least on paper. And no drink could be a better symbol of that excess than the Zombie, which, famously, contains three types of rum, three different syrups, two fruit juices, and, for good measure, dashes of both Pernod and Angostura bitters.

The story goes that Beach invented it for a hungover customer who was headed to a business meeting. The good news was that, after three Zombies, the dude's hangover went away; the bad news is he felt like a Zombie for three days. Apparently, Beach implemented a rule right then and there—a limit of two per customer.

All these years later, it's not only a foundational tiki drink that continues to define the genre; it's also still one of tiki's most popular, challenged only by the Mai Tai, which wouldn't come along for another ten years.

This recipe is based on the tireless research of Jeff Beachbum Berry, perhaps the world's leading tiki drink authority.

SERVES ONE

* 1½ ounces gold rum
* 1½ ounces dark Jamaican rum
* 1 ounce Demerara rum
* ¾ ounce fresh lime juice
* ½ ounce falernum (see recipe note)
* ½ ounce Don's Mix (see recipe note)
* ⅛ ounce grenadine syrup
* 6 drops Pernod
* 1 dash Angostura bitters
* 1 cup crushed ice
* Pineapple wedge, for garnish

Place all ingredients except the pineapple wedge in a blender and blend until the mixture has the consistency of slush. Pour into a tall glass and garnish with the pineapple wedge.

Recipe note: Don's Mix (fresh grapefruit juice mixed with cinnamon syrup) and falernum (a rum-based almond syrup that's heavy on the cloves and lime zest) can both be bought from cocktail-supply vendors. They can also be made fairly easily at home. (Google for recipes.)

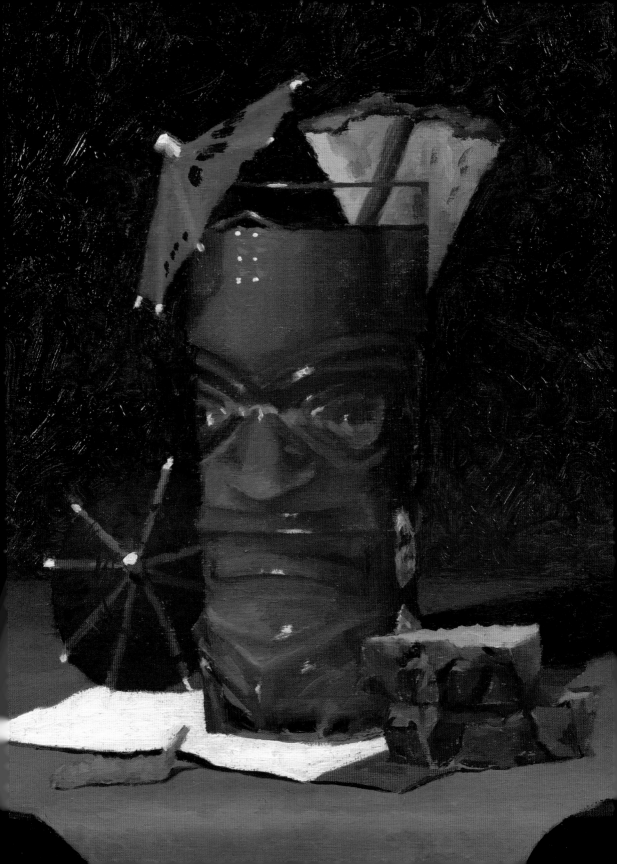

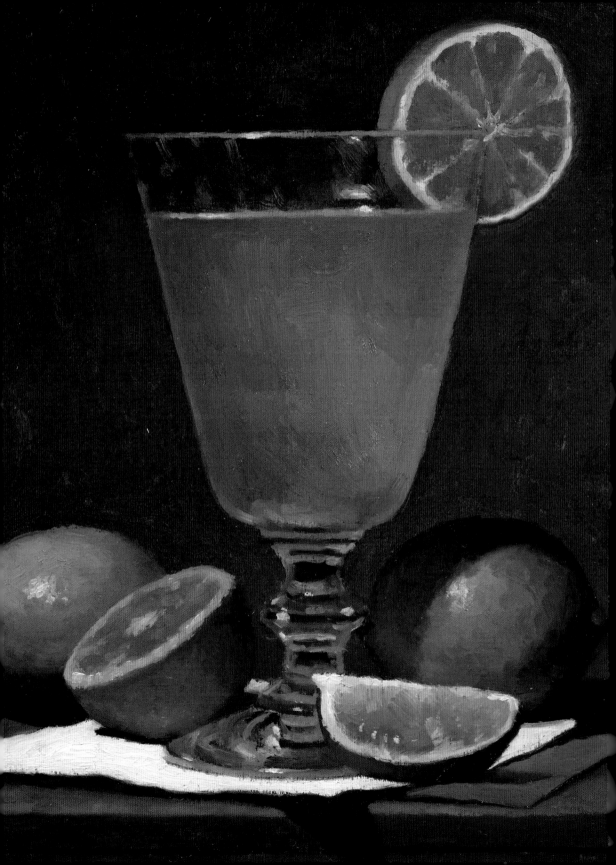

Gimlet

In an era where fresh-squeezed is always heralded as the best, it's difficult to make friends with a recipe that calls for Rose's Lime Cordial, a sugary commercial product that's the antithesis of fresh. It's especially hard to win people over to a recipe that calls for *equal* parts cordial and gin, as bartending great Harry Craddock does in the Gimlet recipe in his *Savoy Cocktail Book*.

Although the *Savoy*, published in 1930, is something of a bible for the craft cocktail cult, not every recipe in the book is a gem. Many bartenders have attempted to salvage some of its recipes, including tweaking the Gimlet by using fresh juice. Despite these efforts, though, Rose's has managed to survive; it's still there in most Gimlet recipes, albeit often in a quantity smaller than that specified by Craddock.

Maybe it's the thrill of transgression that keeps Rose's alive. Perhaps it's a guilty-pleasure thing, like indulging in the occasional Big Mac. Its ongoing presence probably has something to do with the fact that straight juice isn't *at all* the same thing as a cordial, which began as a "health tonic." Rose's is actually an early vitamin C supplement and, like most cordials, has a complex flavor profile and some sharp edges that fresh lime juice lacks.

One day, we imagine, there will be a more natural-tasting "craft" cordial that will make everyone happy. But for now you have two options: Make your peace with Rose's or use fresh lime juice to make a Gimlet that doesn't taste much like a Gimlet at all. Or maybe there's a third option: Our recipe here balances the drink with a tiny bit of fresh lime juice.

SERVES ONE

* Lime wheel, for garnish
* 2½ ounces dry gin
* ½ ounce Rose's Lime Cordial
* ⅛ ounce fresh lime juice

Rim a chilled cocktail glass with the lime wheel. Combine the liquid ingredients in a mixing glass with ice. Stir until well chilled and strain into the cocktail glass. Garnish with lime wheel.

Negroni

The Negroni had its 100th birthday quite recently—a surprising fact when you consider that this centenarian has such a contemporary vibe it could pass for an adolescent. Unlike a lot of other classic cocktails that have been revived over the past decade or two, though, the Negroni never entirely went away. It might have been slightly hard to find during the decades when Screwdrivers and Wallbangers ruled, but it was almost always available at smart cocktail bars.

What's the secret to the Negroni's success? It's simultaneously sophisticated and approachable since it's dead simple to make. The recipe is easy to remember: equal parts gin, Campari, and sweet vermouth. It can be served straight up or on the rocks and is great either way. And since the recipe's no trouble to remember, it's also a safe cocktail to order in a bar that doesn't do craft cocktails. Oh, yeah, and it's also a deliciously well-balanced drink.

SERVES ONE

* 1 ounce gin
* 1 ounce Campari
* 1 ounce sweet vermouth
* Orange peel, for garnish

Pour all the liquid ingredients into a mixing glass with ice. Stir and strain into a chilled coupe or cocktail glass and garnish with the orange peel. (If you wish, you may strain the drink into a rocks glass with ice instead.)

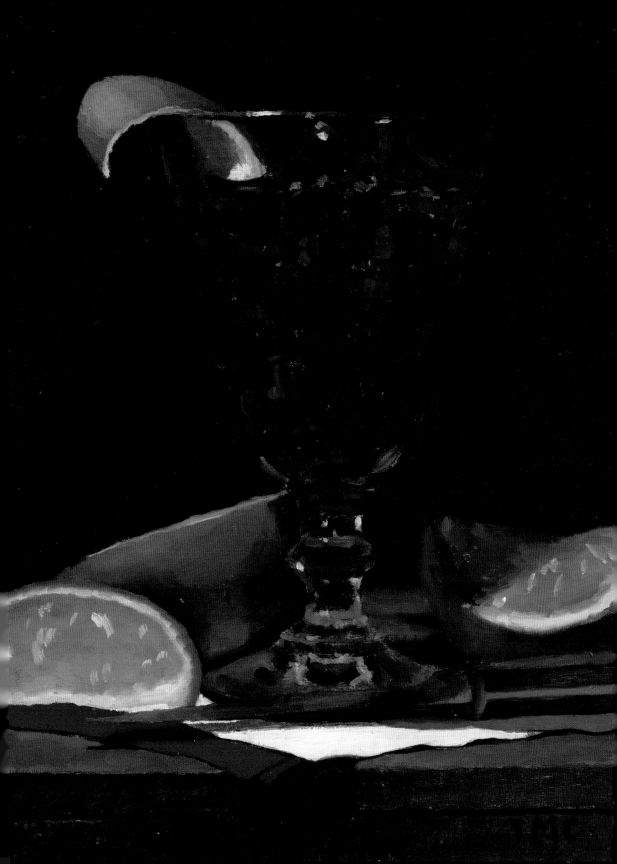

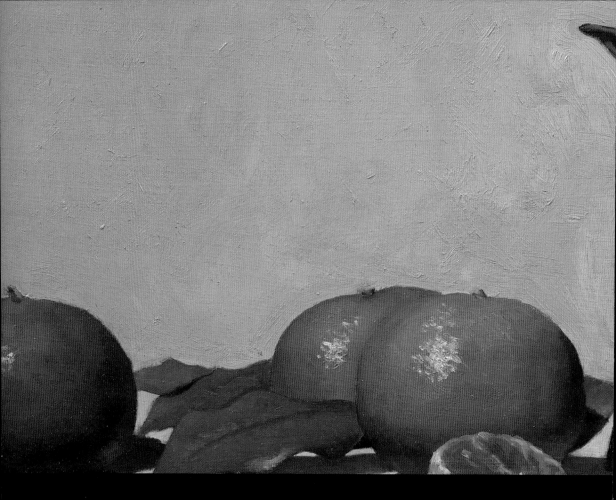

Preparing Cocktails in Batches

The best way to host a great cocktail party is to actually let yourself be a host—*not* a bartender. Sure, showing off your mixological skills to your guests can be fun—but the reality of having to constantly restock the ice and clean the station is less fun, especially since party people can drink cocktails (and need refills) awfully fast.

What the host needs, instead, is to channel *sprezzatura*, the Italian art of making difficult tasks look entirely effortless. What's the secret to *sprezzatura*? When it comes to cocktail parties, it's advance prep. That means pre-batching your cocktails so that when guests arrive, you just have to put the finishing touches on the drink.

Here are a few tips on best cocktail-batching practices:

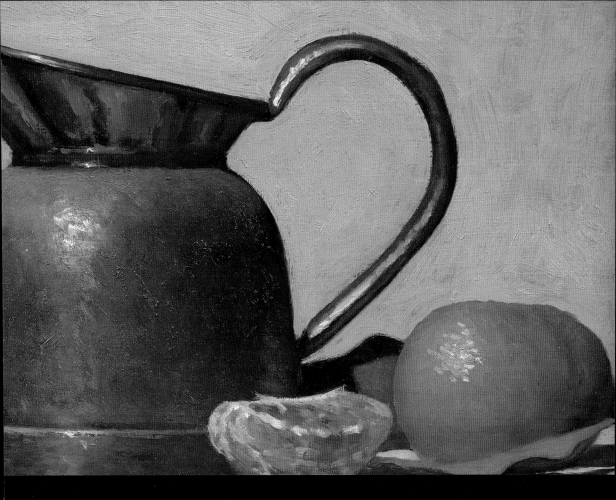

1. With the exception of Christmas eggnog, if a recipe calls for an egg—white, yolk, or whole—do not attempt to turn it into a batch drink. Egg drinks shine their brightest when made to order, with the shaking adding a fluffy texture to the cocktail. The fluff has no staying power, though, so you can't simply "scale up" a recipe.

2. Start your batching adventure with a straight-spirit "equal-parts" cocktail that doesn't call for any sugar, like a Negroni (page 108) or a Boulevardier (equal parts rye whiskey, Campari, and sweet vermouth). Combine all the spirits in a swing-top bottle.

3. Since shaking or stirring a cocktail over ice dilutes the drink as the ice melts, your batched cocktail is going to be too potent unless you add a little water to the mix—roughly one-half ounce per cocktail. Refrigerate. When the guests arrive, just pour over ice (or into a chilled glass), garnish, and serve.

4. Never add sparkling wine, ginger beer, soda, or anything with bubbles to the batch. Instead, do that *à la minute*, pouring the fizzy stuff into the glass just before serving the individual drink.

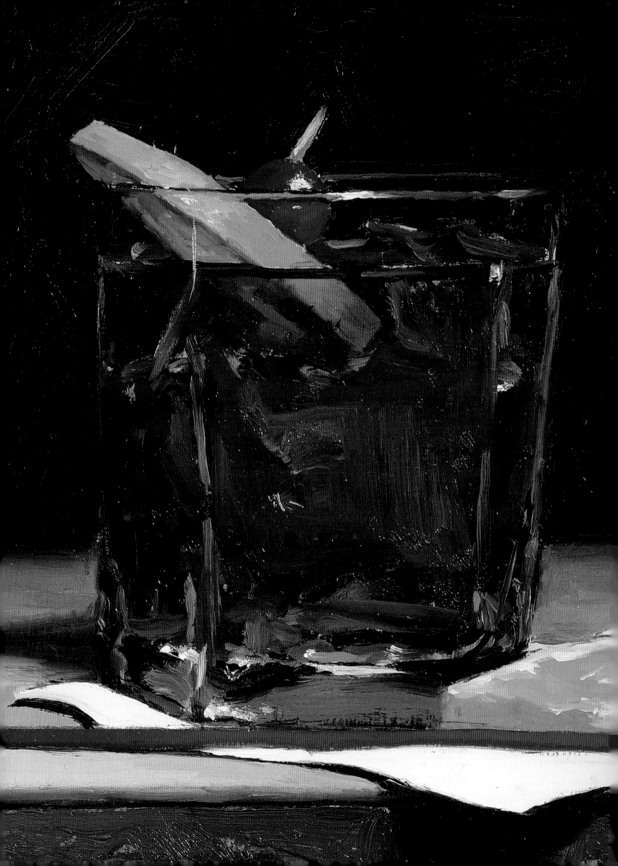

Old Fashioned

Since we're only twenty-some years in, it's probably too soon to call the Old Fashioned revival the comeback of the century. Still, when bartenders slinging drinks in the clubs started reporting they were getting more orders for the Old Fashioned than for vodka-sodas, well, let's just say we didn't have that on our cocktail bingo card.

What's great about this drink is that it's actually more of a technique than a recipe, and while the Old Fashioned should technically be made with whiskey, it's possible to make a great drink by muddling a bitters-soaked sugar cube and adding just about any spirit you can think of. That's what they call timeless.

SERVES ONE

* 1 sugar cube
* 4 dashes Angostura bitters
* A few drops of water or club soda (⅛ ounce at most)
* 2½ ounces rye whiskey
* Fruit, for garnish (optional)

Place the sugar cube in a rocks glass and douse it with the bitters and a few drops of water. Muddle it until it is essentially a syrup. Add whiskey and three large ice cubes. Stir briefly and garnish with fruit, if desired.

Part Four

Celebration

There are certain drinks, from Derby Day Mint Juleps to Christmas Eggnog, that are so intertwined with holidays and other celebrations that they're practically the guest of honor at the party. Many of these traditional libations will be seen only once a year, so selecting their ingredients and preparing the drinks require a great deal of thought and care. As we dust off the cookbook containing the treasured family punch recipe or pick up that brand of bubbly that's accompanied all our most important milestones, the celebration has in a way already begun. These are drinks with a sense of occasion.

Champagne

In fancy restaurants, somms use a napkin to cover the cork, gently easing it out of the bottle and thereby muting Champagne's signature "pop." On the other end of the spectrum are the folks who live for the spectacle and open each fresh bottle of Champagne by sabering off the bottle's neck—glass and all. (And don't get us started on celebrating a team's victory by spraying bubbly all over the locker room. What a waste of good fizz!)

Most of us fall somewhere between these extremes. We let the cork fly out of the bottle, making a little noise and adding a touch of drama to make it clear that the sparkling wine isn't just a dinner companion. Rather, it's there to mark a special birthday, or a ship's maiden voyage, or a good friend's wedding, or New Year's Eve—the night we kiss last year goodbye and, at the same time, the person next to us.

Champagne is a celebration of love and the ultimate signifier of both a shared past and new beginnings. And given all that significance, we think it's perfectly fine to make a little noise. Great all by itself, Champagne is also splendid as the base for the justly famous Champagne Cocktail.

Champagne Cocktail

SERVES ONE

* 1 sugar cube
* Angostura bitters
* 5 ounces Champagne
* Lemon twist, for garnish (optional)

Soak the sugar cube with the bitters and then place the sugar cube in a flute glass. Fill the glass with Champagne and, if desired, garnish with the twist.

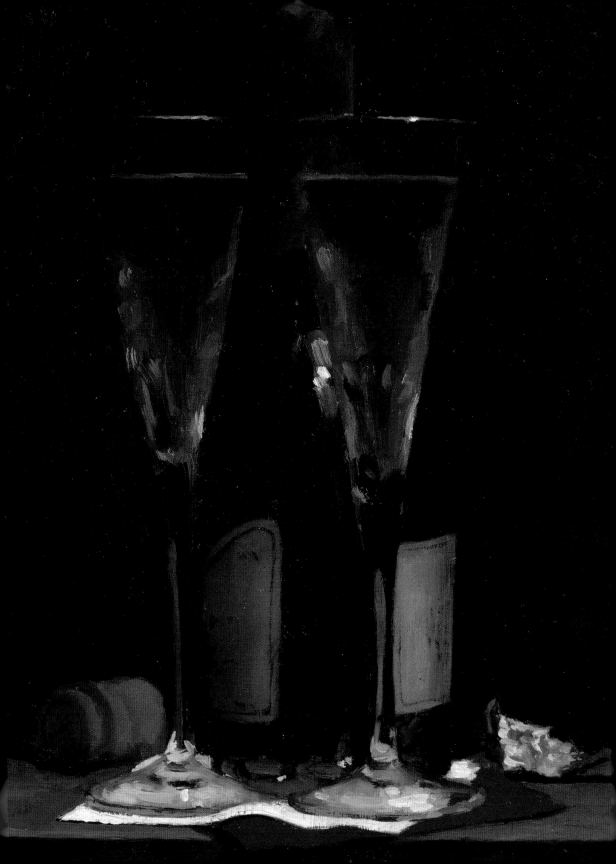

Tequila Pairings

Tequila is surprisingly food-friendly. Good tequila, that is. It's a natural partner for raw fish dishes like ceviche and for tomato-based shrimp and oyster *cocteles*, such as the *Vuelva à la Vida* ("Return to Life") hangover cure. But tequila also pairs incredibly well with cheese, chocolate, and dried fruits. You must, however, pick the right tequila for the job.

Blanco tequila goes best with bright, citrus-forward, and spicy appetizers, including fish tacos, ceviche tostadas, pineapple salads, and pretty much anything accompanied by a tangy salsa verde.

Reposado tequila, with its touch of vanilla, plays very well with hard cheeses with a sharp edge, such as manchego and gruyère, particularly when they're paired, in turn, with dried apricots or tart orange marmalade on toast.

Possibly the best tequila pairings of all come with dessert, matching up a rich *añejo* with a traditional flan, crème brulée, or, best of all, a piece of dark chocolate dusted with a little ancho chili pepper. Delicious.

Day of the Dead

Paintings and figurines of well-dressed skeletons celebrating or just doing everyday things are instantly recognizable representations of one of Mexico's best-known traditions. On *Día de los Muertos* ("Day of the Dead"), which takes place each year on All Souls' Day (November 2), people bring tamales, bread, and tequila to the graves of their loved ones. There, they eat, drink, tell stories and jokes, and honor those who have passed by remembering them living their best lives.

Although the roots of this celebration go back to both pre-Columbian and Catholic traditions and rituals, elegantly dressed skeletons only became an integral symbol of *Día de los Muertos* in the early twentieth century. The imagery can be traced to *La Calavera Catrina* ("The Dapper Skull"), an etching by Mexican artist José Guadalupe Posada. Posada used images of skulls as part of his political critique of the Porfirio Díaz dictatorship, a corrupt, materialistic, and anti-indigenous administration that exacerbated inequality in Mexico. By drawing attention to our mortality, Posada reminded us that we are all equal in death, no matter how fancy a life we lived.

Tequila Blanco

A really great tequila has nothing to hide. That's why so many hard-core agave-philes are purists who prefer an unaged *blanco* over *reposado* ("rested" in an oak barrel for two months to a year) or *añejo* ("aged" in oak for one to three years).

With tequila, they think, no wood is required. That opinion flies in the face of experts' preferences in so many other spirits categories. Whiskey, rum, and cognac all generally improve with barrel aging, at least up to a point. But those spirits start out young—grain, sugarcane, and grapes are all under a year old when plucked for harvest. Agave, on the other hand, has already spent years soaking up the sun and soil before the *jimadors* extract its rich, sweet *piña*—the heart of the plant, from which the spirit is made.

The agave has already done almost all the work. Tequila-makers' only challenge is to keep its essence intact. And when they do a good job with that, you'll want to taste it all by itself. But sometimes it's fun to have it in a cocktail, too, like this twist on a Black Russian.

Brave Bull

SERVES ONE

* 2 ounces blanco tequila
* 1 ounce Kahlúa
 coffee liqueur

Add the ingredients to an ice-filled rocks glass. Stir briefly and serve.

Mezcal and Sangrita

There's a tiny little bar in the city of Oaxaca called Mezcalería in Situ, which has about seven or eight barstools, a couple of small tables, and roughly four hundred bottles of mezcal. There are no cocktails on offer, only "flights" of different mezcal varieties. Your order is served in cups that come with little cards—sort of like baseball cards, except that instead of stats and a picture of a player, each card shows an image of the species of wild agave from which that mezcal is made, as well as a little information about it.

Trying to collect them all would be a complicated game, given that the mezcal catalog includes a dizzying range of expressions. Some mezcals are classified by the type of agave used, but others are identified by the place (usually a town) where they are produced.

Our favorite way to drink mezcal is with Sangrita ("little blood"), a delicious "chaser" that's a complex blend of sweetness, heat, salt, and acidity. It plays a role in a thoroughly civilized ritual that involves slowly taking a sip of spirit and following it with a sip of Sangrita—the perfect way to wind down a great dinner party with friends.

Sangrita

SERVES TWELVE

* ¼ cup minced onion
* 3 whole jalapeño peppers, cut lengthwise in half
* 3 fresh poblano chilies, chopped roughly
* 2 dried ancho chilies
* ½ cup pomegranate seeds
* 8 ounces fresh pomegranate juice
* 8 ounces fresh lime juice
* 16 ounces fresh-squeezed orange juice
* 2 teaspoons sea salt

In a large bowl or another container, mix all the ingredients together, cover, and refrigerate for twenty-four hours, allowing the ingredients to meld. Taste to make sure you have the right balance of sweet, salty, spicy, and sour. If it's not spicy enough, add more peppers (and whatever else may be lacking) and put the bowl back in the refrigerator for another twenty-four hours. Strain solids out with cheesecloth or a fine-mesh strainer, bottle, and refrigerate for up to a week.

To serve, pour Del Maguey Single Village Tobalá (or your favorite mezcal) into a shot glass and Sangrita into a second similar glass. Alternate sips between the two.

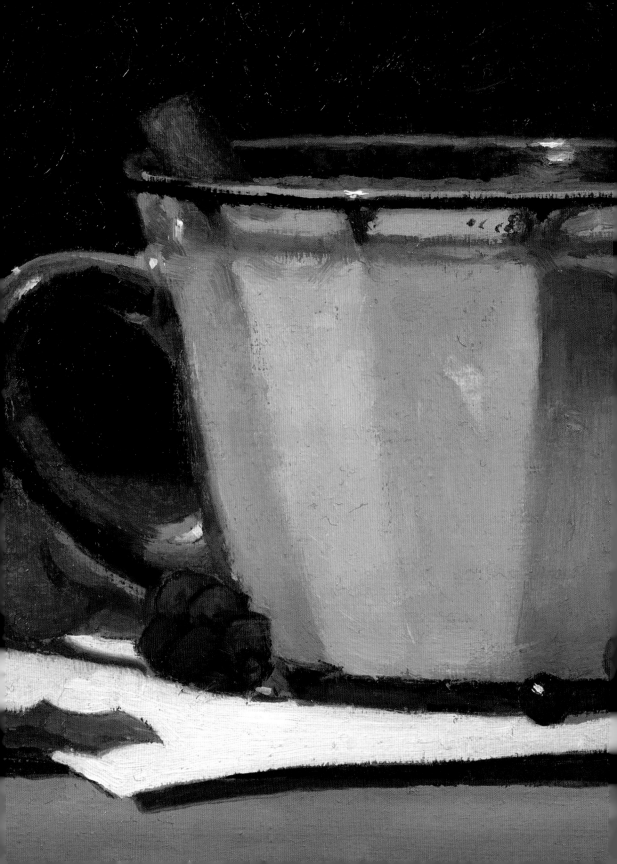

Eggnog

No matter how good that brand of artisanal craft eggnog you discovered at the local farmer's market is, nothing compares to a fresh homemade batch, based on a rich, decadent old formula. It's not so much that using a recipe like this gives you license to go full-fat (although it does). Instead, it's because traditional eggnog recipes—which instruct the home bartender to separate the eggs and whip up the whites and yolks separately—are rooted in solid baking techniques and make for superior nog. The whipped egg whites aerate the drink, imparting a fluffy and light consistency. Without this step, the drink can veer into boozy French toast batter territory. (And let's not even mention generic supermarket eggnog!)

SERVES SIXTEEN (FOUR-OUNCE SERVINGS)

* 6 egg yolks
* ¾ cup granulated sugar, divided
* 1 quart whole milk
* 2 cups heavy whipping cream
* 6 ounces rye whiskey, chilled
* 6 ounces dark, aged rum, chilled
* 6 egg whites
* Freshly grated nutmeg, for garnish
* Cinnamon sticks, for garnish (optional)

In a large bowl, beat the egg yolks, gradually adding ½ cup of sugar as you beat. When the sugar is thoroughly dissolved (about 90 seconds) and the yolks are light yellow in color, add the milk, cream, whiskey, and rum, and mix. In a separate bowl, beat the egg whites together with ¼ cup of sugar until stiff peaks form, roughly two to three minutes. Fold the beaten whites into the egg yolk mixture, continuing to gently fold until the texture is even. Ladle into punch cups, garnishing each with a sprinkle of grated nutmeg and, if desired, a cinnamon stick.

Pisco Punch

One of the most surprising things about drinking habits in post–Gold Rush San Francisco is that the "it" drink of the late 1800s wasn't two fingers of whiskey (neat), but rather a punch made with imported grape brandy from Peru. Sounds like San Fran*pisco* was ahead of its time when it came to cocktail trends.

Okay, we're sure they had plenty of whiskey, too, but South American pisco was incredibly popular in the Golden Gate City as a result of shipping and migration routes that brought transient prospectors to sites up and down the West Coast of the Americas. At San Francisco's Bank Exchange bar, owner and bartender Duncan Nicol decided the abundant pisco he had access to would be even tastier if it were mixed into a punch with pineapple and citrus.

It still is a garden party staple and a perennial hit. The only word of warning we'd give to a host is to make way more than you think you'll need. We've never seen a punch disappear so quickly in a crowd of mostly reasonable people.

SERVES TEN (FIVE-OUNCE PUNCH CUPS)

* 26 ounces pisco
* 8 ounces fresh lemon juice
* 8 ounces cold water
* 8 ounces pineapple gum syrup (see recipe note)
* Pineapple slices, for garnish
* Lemon, cut into wheels, for garnish

Stir all liquid ingredients together in a large punch bowl or pitcher. Add fresh pineapple slices, lemon wheels, and ice. Chill with a block of ice or the largest cubes you can find to prevent over-dilution.

Recipe note: Pineapple gum syrup can be bought at good cocktail supply shops and is readily available online. In a pinch, infuse simple syrup with pineapple chunks.

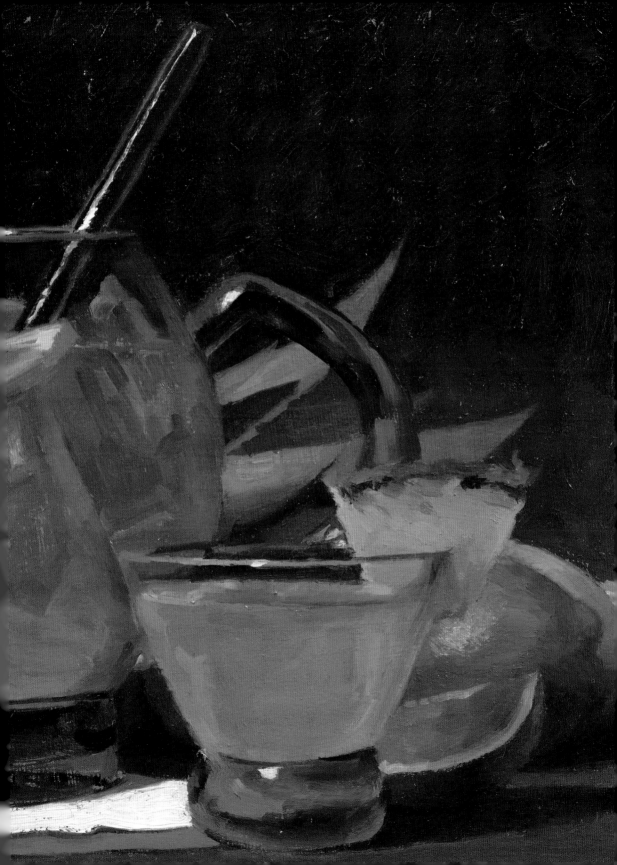

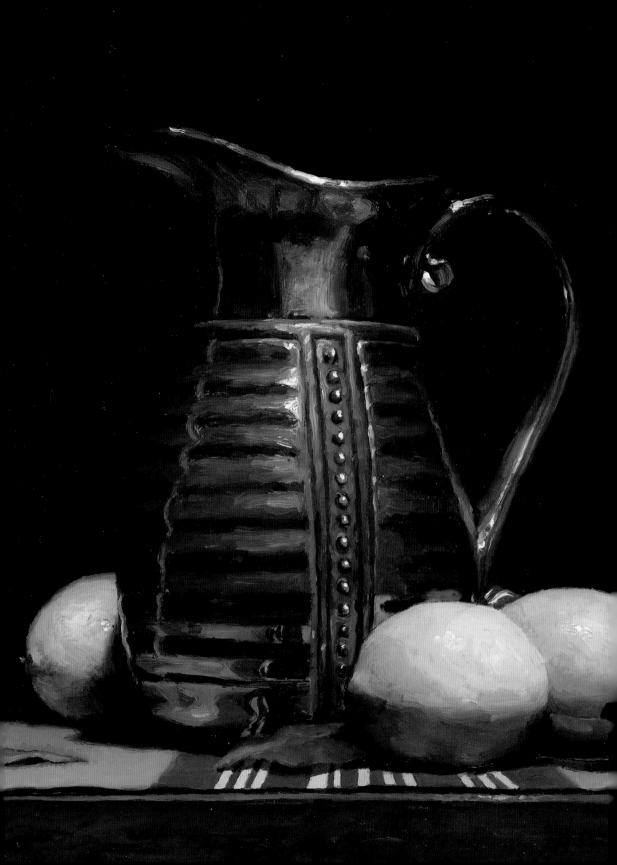

Citrus

"One part sour, two of sweet, three of strong, four of weak." This ancient and oft-quoted formula for punch isn't just a good rule of thumb for building balanced drinks; it's also testament to the age-old understanding of the importance of citrus in cocktails. At first, the marriage of spirits and citrus was a "wellness" trend, as British sailors—"limeys," they were dubbed—drank lime and lemon juice preserved with alcohol to prevent scurvy on long voyages. As an added bonus, everyone agreed that citrus improved the flavor profile of the rustic spirits of the day, smoothing over the rough edges.

Although it wasn't known at the time, the reason is that citrus tamps down the bite and burn of ethyl alcohol. And because lemons' and limes' acidity is so powerful, citrus acts as a perfect balance to spirits, especially punchy white spirits like tequila, gin, and pisco. Of course, there's more to crafting perfectly balanced cocktails than just adding citrus. For that you need the second half of the famous punch rhyme: "A dash of bitters and sprinkle of spice, serve well chilled with plenty of ice."

Margarita

When Cinco de Mayo is bad, it's very, very bad. But when Cinco de Mayo is good, it's wonderful.

Let's get this out of the way: Cinco de Mayo isn't Mexico's Independence Day, a celebration that actually falls on September 16. Instead, May 5 marks the Battle of Puebla, a decisive 1862 skirmish that cemented Mexico's victory over France. The battle was significant but, by and large, Mexicans outside the state of Puebla pay its anniversary little attention.

Americans, on the other hand, seize the day as an occasion to drink all the Margaritas and load up on all the tacos they can. Nothing wrong with that, in and of itself, but it has given rise to some offensive rituals, like people dressing up in sombreros and speaking with a "funny" accent.

That said, plenty of deeply respectful celebrations are taking place everywhere and every year on the Fifth of May. Cinco de Mayo is an opportunity to delve into the history and culture of a fascinating, diverse country, including its amazing food and drink traditions. Indulge in a Margarita, sure. But don't stop there. Let this holiday be an invitation to learn more.

SERVES ONE

* Salt, for rimming the glass
* 2 ounces tequila blanco
* 1 ounce fresh lime juice
* ½ ounce agave syrup
* Lime wheel, for garnish

Wet the lip of a margarita glass or cocktail glass with the lime wheel and rim the glass in salt. Pour the tequila, lime juice, and agave syrup into a cocktail shaker over ice and shake well. Strain into the prepared glass and garnish with the lime wheel.

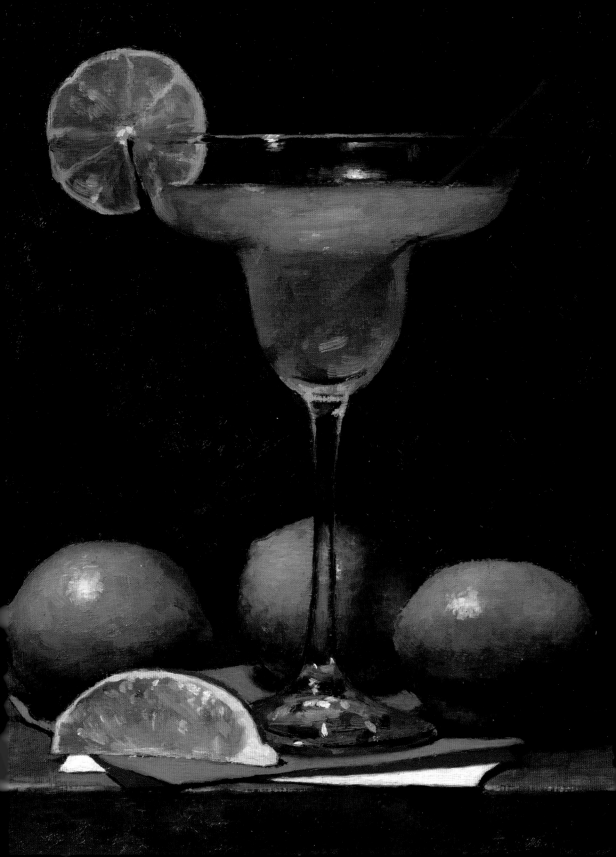

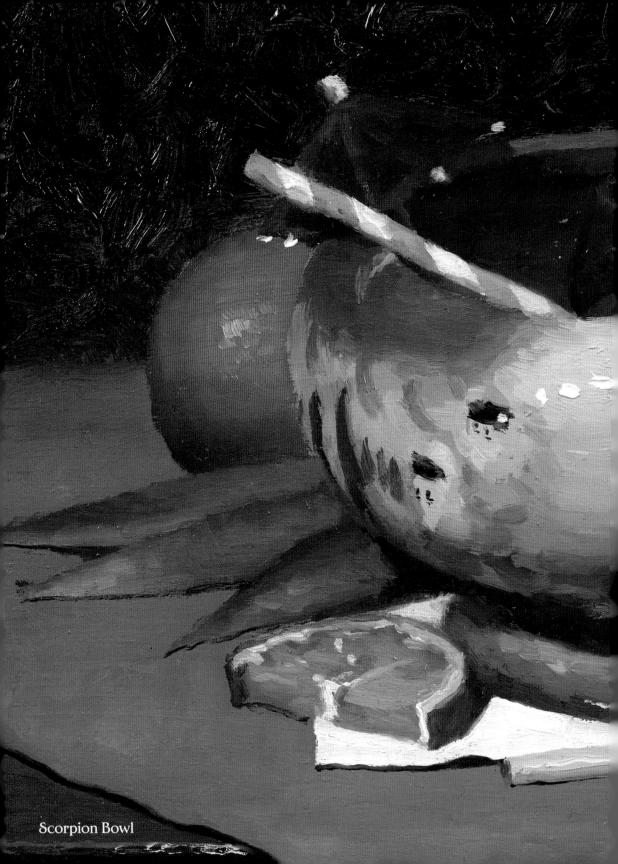

Scorpion Bowl

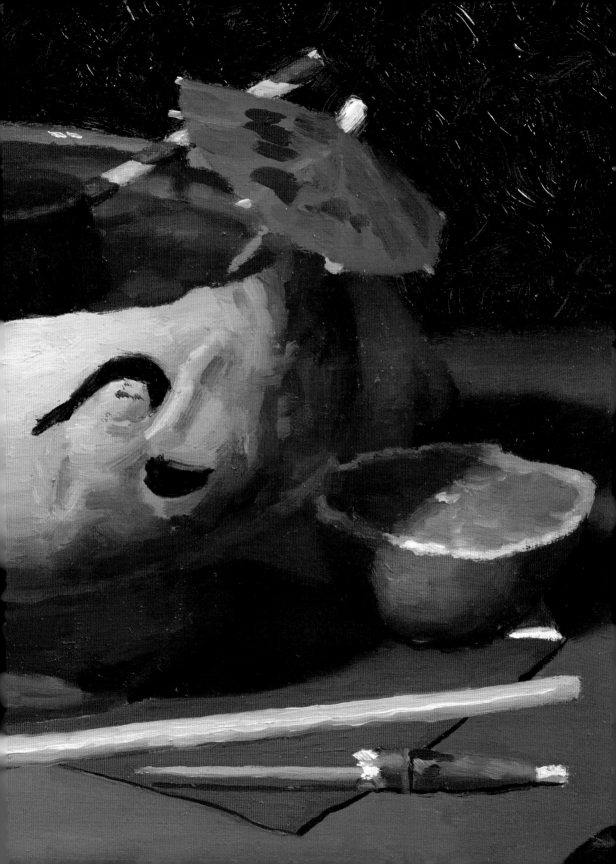

Scorpion Bowl

Punch is the most convivial of beverages. As the centerpiece at a great party, it ensures that everyone has something in common—they're all drinking from the same shared bowl.

The Scorpion Bowl takes communal drinking to the next level, since, with the help of comically long straws, people drink *directly* from the same bowl instead of using glasses. Of course, this isn't the sort of thing you can serve at a gala event with lots of strangers. The Scorpion Bowl is designed for more intimate celebrations—a party of four, say, who already know each other pretty well and don't mind huddling close. Not too close, though, since the most popular type of this mid-century tiki punch is a Volcano Bowl, which has a crater in the middle designed to hold overproof rum. When the rum is lit, a bright flame shoots up from the center.

Sure, the spectacle of a flaming Scorpion Bowl is a little to the left of good taste. But bonding with friends over communal drinks and a fire pit is, quite frankly, what we are hardwired to do. So, our advice? Lean in.

SERVES FOUR

* 4 ounces lightly aged amber rum
* 4 ounces dry gin
* 2 ounces brandy
* 3 ounces fresh orange juice
* 3 ounces fresh lime juice
* 1½ ounces simple syrup
* 1½ ounces orgeat syrup
* 2 cups crushed ice
* 2 ounces overproof Wray & Nephew white rum (for Volcano Bowl option; see recipe note)

Place all ingredients except the overproof rum in a blender and blend on high for 5 to 10 seconds. Pour into a scorpion bowl. Drink with long straws.

Recipe note: To take it up a notch and transform it into a flaming Volcano Bowl, carefully add overproof rum to the central well in the bowl and set aflame. Drink with long straws.

What Is Tiki, Anyway?

Tiki isn't Polynesian. Not even close—although one of the founders of tiki—Donn Beach—did claim to have spent time in the South Pacific. Then again, he claimed a lot of things.

The first tiki bar, Don the Beachcomber, was established in Hollywood in 1933—mere moments after Prohibition was repealed. It was also three-and-counting years into the Great Depression, and times were hard all around, so the Beachcomber bar was opened as a sanctuary from reality. Donn obviously wasn't too worried about the number of n's in his nickname—nor, more importantly, about authenticity or cultural appropriation. He felt perfectly comfortable with conjured-up stereotypes of a fantasy world where people were free and unencumbered by the hardships of 1930s America. Much of what he cobbled together was probably gleaned from paintings and memoirs of fantasists and fabulists before him, including Paul Gauguin (who, incidentally, is thought to have made up a lot of his Tahitian travelogue, *Noa Noa*).

This doesn't make it right, of course, especially when you see the sexualized representations of Polynesian women dressed in leis and grass skirts being used to sell drinks with excessive amounts of rum. We like to think, though, that the "modern tiki" movement that's started to evolve can redress some of the worst abuses of the genre and salvage it to the point where it's no longer about having fun at somebody else's expense. We still have plenty of reasons to need an occasional escape, so here's hoping there's a way to reform tiki and save it.

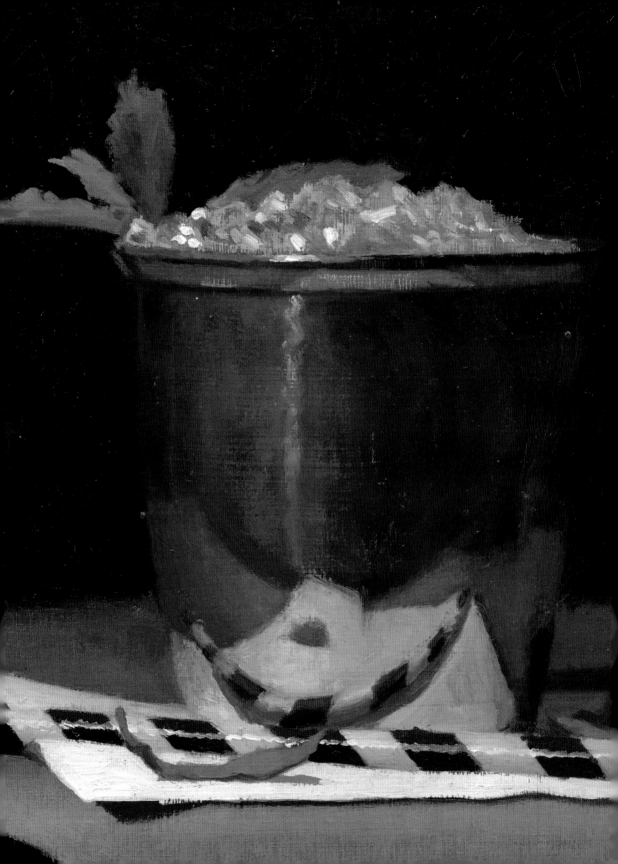

Mint Julep

The mint juleps at Churchill Downs are not the *very* best we've ever tasted. But after a couple, they *do* start to grow on you. And, to be fair, when you're trying to make over 100,000 juleps at a time—as they do on Derby Day—it's hard to maintain quality control.

The many Southern literary types who have written odes to the drink and tracts about how to construct it perfectly are unlikely to be as generous as we are about the juleps for the masses who descend on Louisville to celebrate the most exciting two minutes in sports. But while we think some of their writings on the matter are a little self-indulgent, we do believe these authors' recipes hold the key to making the very best drink. The best julep is, essentially, just an excuse to drink bourbon with as little interference from the sugar and water as possible.

SERVES ONE

* ¼ ounce rich simple syrup (2 parts sugar to 1 part water)
* 2 sprigs mint
* 3 ounces bourbon, divided
* 1½ cups crushed ice

In a silver or pewter julep cup, gently muddle together the rich simple syrup and the leaves from 1 sprig of mint, making sure to press the leaves all around the inside of the cup right up to the rim so that the mint oils cover the entire interior surface. Add 1 ounce of bourbon and stir. Add half the crushed ice and stir again. Fill with ice and pour in the rest of the bourbon. Add more ice, mounding it above the cup's lip, and garnish with the second sprig of mint. Serve with a straw.

French 75

"Hits with remarkable precision." That's all that Harry Craddock, author of the 1930 *Savoy Cocktail Book,* had to say about this potent drink, which is said to be named after a piece of World War I artillery. Indeed, the French 75, like most Champagne cocktails, all but guarantees heavy damage, since the last thing a fizzy, easy-to-drink libation really needs is an additional shot of straight liquor.

There is considerable debate about how to make this drink, which is sometimes served as a straightforward Champagne cocktail in a flute and sometimes as a long drink served in a collins glass over ice. We're going with the latter since, to our taste, it's a better drink and, besides, it's closer to the original served at Harry's New York Bar in Paris. We suggest pairing it with a hot dog so you can fully re-create the ambience of this legendary bar at 5 rue Daunou, no matter where in the world you might be.

SERVES ONE

* 1 ounce dry gin
* 1 ounce fresh lemon juice
* ½ ounce rich simple syrup (2 parts sugar to 1 part water)
* 3 to 4 ounces chilled dry Champagne
* Lemon twist, for garnish

Pour the gin, lemon juice, and rich simple syrup into a cocktail shaker over ice. Shake well and strain into a collins glass filled with ice cubes. Top with Champagne. Garnish with the twist of lemon.

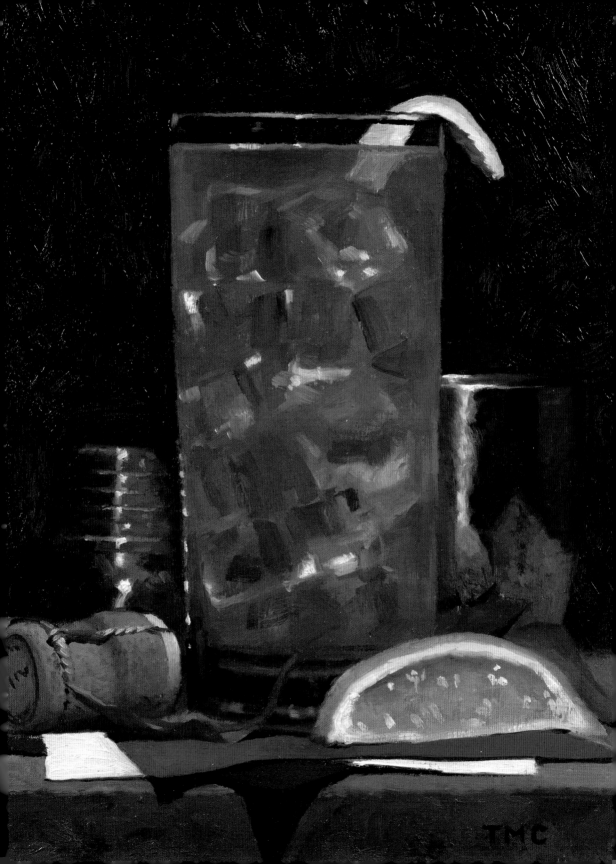

After Dinner and before Bed

Once upon a time, long before central heating, bedtime was more of an event. People even wore special bedtime hats, which they, of course, called nightcaps, and which they wore when they took a little nip of whiskey or brandy before bed or, sometimes, even *after* they'd tucked themselves in. You have to keep your insides warm, too, right?

Now, except perhaps at a chilly cottage, nighttime headwear has mostly been retired. Fortunately, the drink component of the nightcap survived and, in fact, thrived, as it evolved from a straightforward end-of-night dram into hundreds of different beverages, from spiked coffees (decaf, please!) to fancy layered drinks.

Whatever it looks like, we're happy to have it, because no matter how good modern heating is, there are still times when we need to warm up our insides.

Death Flip

When designing a new cocktail recipe, you sometimes have to find a way to bring disparate intense flavors together. Over the years, bartenders have developed a little trick for this—the "put an egg in it" rule. No matter how bizarre the ingredients are or how unlikely it might seem that they'd ever get along in a cocktail, adding a whole egg to the drink is nearly always a magical way to smooth out the differences.

The Death Flip—a modern classic invented by Australian bartender Chris Hysted-Adams from Australia that mixes tequila, Jägermeister, and yellow Chartreuse—is the best example of this rule, since nobody ever saw those three ingredients on a back bar and thought, "Well, there's a natural combo."

That's the brilliance of flips, a family of egg drinks that date back at least as far as the mid-1800s. You can find flips that are even older than that, but their recipes don't always call for an egg. Nowadays, an egg is a defining ingredient of the genre, as in this absolutely delicious cocktail. So don't be afraid. Just put an egg in it.

SERVES ONE

* 1 ounce tequila
* ½ ounce Jägermeister
* ½ ounce yellow Chartreuse
* ¼ ounce rich simple syrup
 (2 parts sugar to
 1 part water)
* 1 fresh egg
 (see recipe note)
* Freshly ground nutmeg,
 for garnish

Place all ingredients except the nutmeg in a cocktail shaker over ice. Shake until the cocktail shaker is ice cold. Strain into a chilled coupe or cocktail glass. Sprinkle nutmeg on top.

Recipe note: We know some people are squeamish about raw eggs in drinks and dressings. As a general rule, it's important to store eggs properly, check the shells for cracks before using and, also, to crack the egg in a separate bowl first (as opposed to directly into the cocktail), so you can make sure it's a good one. If, for whatever reason, this ingredient takes you out of your comfort zone, you might want to skip the flip.

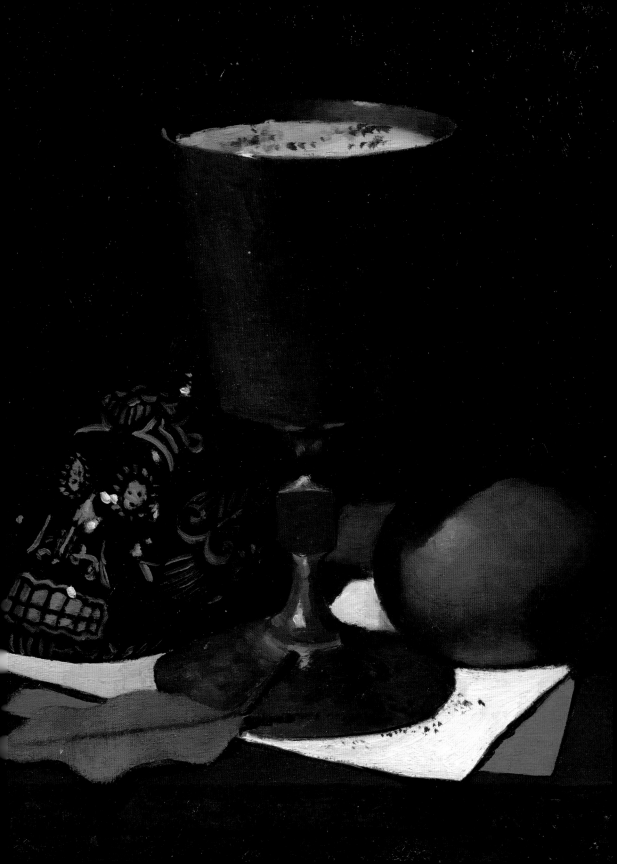

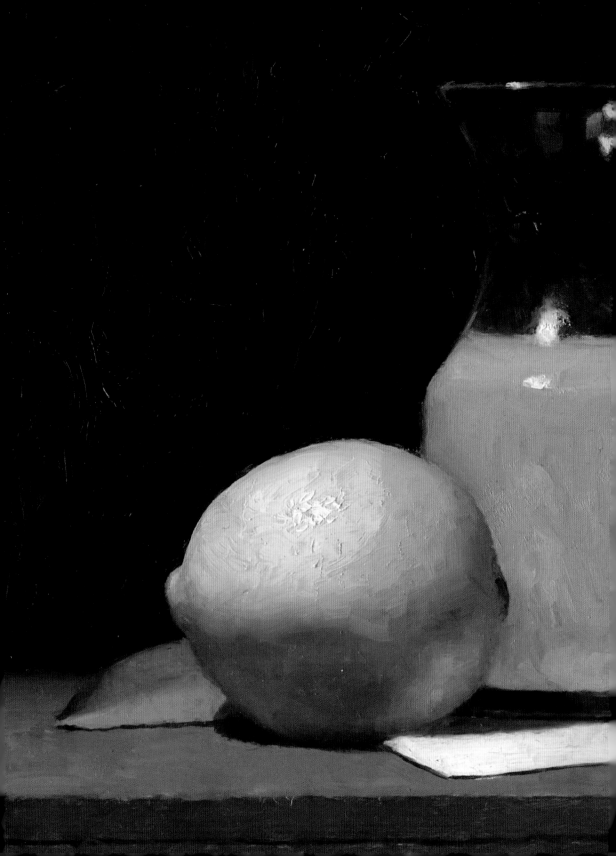

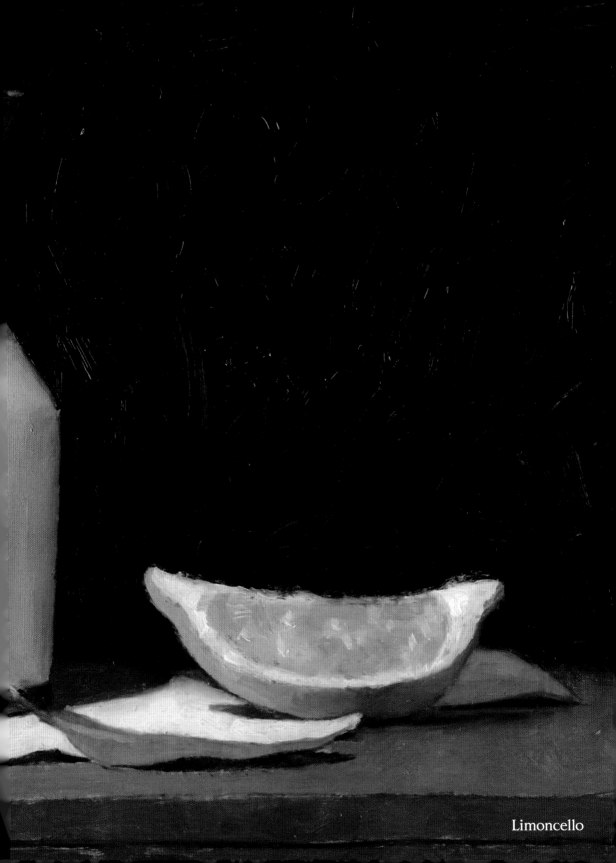

Limoncello

Limoncello

When life gives you giant lemons with thick skins oozing aromatic oils, don't waste them on lemonade. They sure haven't on the Amalfi Coast, where the Sfusato di Amalfi lemon inspired the entire region's cuisine and the flavor of everything from fish to dessert is infused with some part of the oversized citrus fruit—leaves, skin, pith, or juice. Roughly three times the size of an average lemon, the Sfusato is at the heart of all the food and drink traditions there, including, of course, Limoncello, a liqueur made from lemon peels.

To make this Limoncello, you'll need a one-liter glass bottle that can be stoppered tightly and a Microplane grater (or some other super-sharp grater) capable of grating lemon zest very finely. You'll also need a kitchen funnel, a long-handled bar spoon (or some similar implement) for pushing the lemon zest through the funnel and into the bottle, a sieve, cheesecloth, and a large (quart-size) spouted measuring cup. Make sure that all your equipment is very clean, with no trace of soap residue. (Note that our Limoncello recipe calls for ordinary, grocery-store lemons. It's not as exquisite as the lemon liqueurs you'll find on the Amalfi coast, but it's pretty darned good.)

The lemons peak from May to October and the harvest marks the start of the liqueur-making season, preserving the gorgeous aroma for enjoyment long after the last fruit is picked—a quintessentially Italian thing to do.

APPROXIMATELY
SIXTEEN SERVINGS

* 12 very fresh lemons, ideally wax-free and organic
* 750 ml bottle vodka
* ⅓ cup or more simple syrup

Make the Limoncello in two steps:

Step 1: Grate the zest of the lemons very finely. As you grate, try to avoid grating the albedo—the white, pithy part of the rind. If your grated zest contains too much albedo, the Limoncello will be bitter.

Place a funnel in the mouth of a 1-liter bottle. Transfer about a tablespoon of the grated zest to the funnel and pour just enough vodka into the funnel to wash the grated zest into the bottle. Repeat this—washing a little bit of grated zest into the bottle with as little vodka as possible—until all the zest and vodka

are in the bottle. This procedure probably won't work perfectly, so you may need to force some of the zest through the funnel using the handle of a barspoon (or some other implement with a long narrow handle). Stopper the bottle tightly and put it in a cool, dark place, where it will rest for three weeks.

Step 2: After three weeks have passed, take the bottle from its hiding place. Line a sieve with several layers of cheesecloth and set it atop a large, spouted measuring cup. Carefully pour the contents of the bottle through the cheesecloth-lined sieve into the measuring cup. Add ⅓ cup simple syrup to the liquid in the measuring cup and stir. Taste the mixture. If it does not seem sweet enough to you, add more simple syrup—a teaspoonful at a time, tasting after each addition—until the desired sweetness is achieved.

Rinse the bottle thoroughly (no bits of lemon zest should remain inside). Pour the Limoncello into the clean bottle and stopper it tightly. Limoncello is best served ice-cold, so store the bottle in the freezer, where the Limoncello will remain fresh indefinitely.

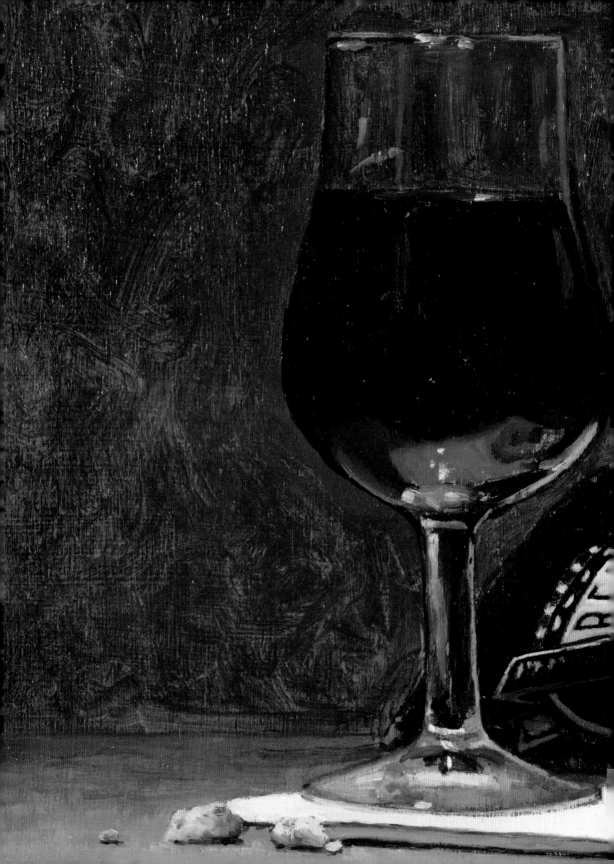

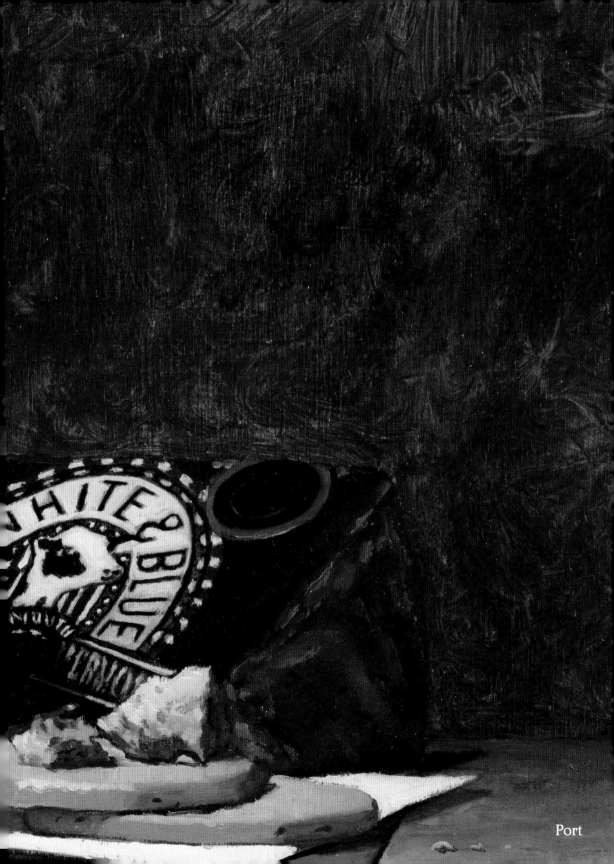

Port

Port

Is port wine Portuguese? Or is it British? Well, a little bit of both. Although it's definitely made in Portugal, many of the port houses in Vila Nova de Gaia—which is across the Douro River from the city of Porto—have posh-sounding British names like Croft, Sandeman, Graham's, and Warre's. This is the legacy of eighteenth- and nineteenth-century English wine merchants who, forced by the Crown to boycott French wines, turned to Portugal.

There was just one hitch; namely, that the voyage from the Douro to the Thames was a little long. To keep the wine from spoiling, the merchants fortified it by adding a little unaged brandy to young wine from the Douro region, upriver from Porto. Rather than traveling inland to blend in the brandy, these merchants established port houses just uphill from the shipping docks. When they were done, all they had to do was roll the barrels down the hill and load them onto the boats.

Port and cheese—especially blue cheese—make for a superlative snack or after-dinner combo. But port can also serve as the base for a range of delicious cocktails. The Port of New York is one of our favorites.

Port of New York

SERVES ONE
* 2 ounces rye whiskey
* 1 ounce 10-year-old tawny port
* 3 dashes Angostura bitters
* 1 maraschino cherry

Stir all ingredients except the cherry in an ice-filled mixing glass. Strain into a chilled coupe or cocktail glass. Garnish with the cherry.

Port Glossary

Don't know port from starboard? If you're having trouble navigating the complex world of port, you're not alone. Here's a little primer on four of the most common styles.

- **RUBY PORT.** Bright red in color and juicy, fresh, and fruity on the palate, this style serves as a perfect introduction to port. Ruby port works well in cocktails.
- **TAWNY PORT.** There's a wide range of tawny ports, but the best of these oxidized wines taste nutty, buttery, and slightly sweet, making them easy-drinking and exceptionally friendly with hard cheese and fruit.
- **VINTAGE PORT.** As with Champagne, vintage port comes from a single harvest that's been declared "outstanding"—a decision that's made after the port has spent a little time in a barrel and started to mature. Vintage ports should be savored on their own.
- **WHITE PORT.** Made from white grapes, white port is often a little too sweet to drink straight. Add a little tonic to it, as they do in Porto's lovely riverfront cafés.

Irish Coffee

In Vienna's vibrant coffeehouses, you constantly find yourself faced with a crucial dilemma: Should whatever you order be served *mit Schlag* (with whipped cream) or not? Boozy coffee *mit Schlag* was probably first served in Vienna, so many people consider Irish Coffee a descendent of this grand and decadent tradition of Central Europe, where the cafés usually combine espresso with kirsch, brandy, or rum.

Regardless of where the practice started, Ireland owns it now, since its version of coffee-plus-liquor-plus-cream is the most famous in the world. Part of the reason, we think, is the slightly runny, slightly sweetened cream that is slowly and carefully spooned onto the top of the coffee (as opposed to being squirted from a whipped cream canister). It's a small detail, but it somehow makes all the difference in the world.

SERVES ONE

* 4 ounces good hot coffee (we use a long shot of espresso)
* 2 ounces Irish whiskey
* 3 ounces thick, sweetened heavy whipping cream
* 1 teaspoon sugar
* Drop of vanilla extract

Pour coffee and whiskey into a heatproof glass coffee mug. Gently beat or whisk the cream with a teaspoon of sugar and a drop of vanilla extract until it is thick but not stiff. Carefully spoon the cream on top of the coffee to make an even layer.

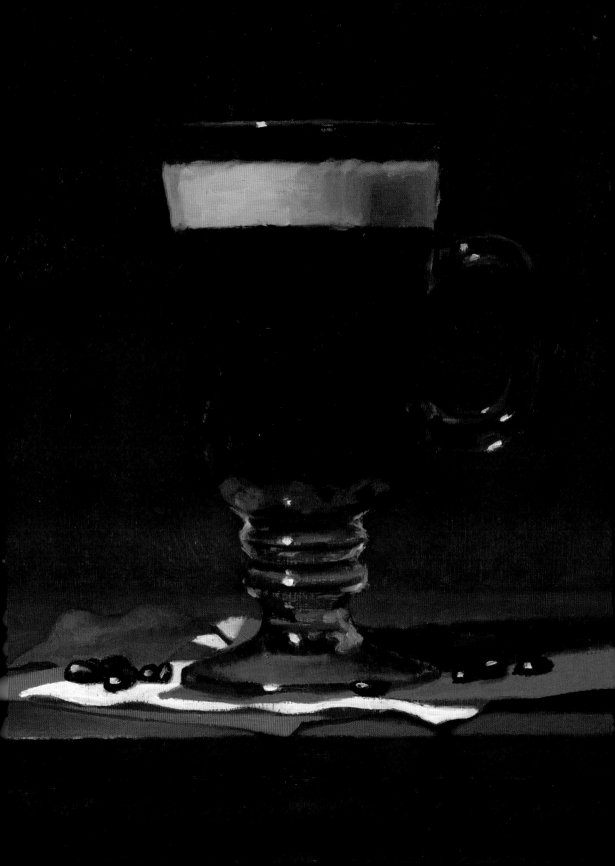

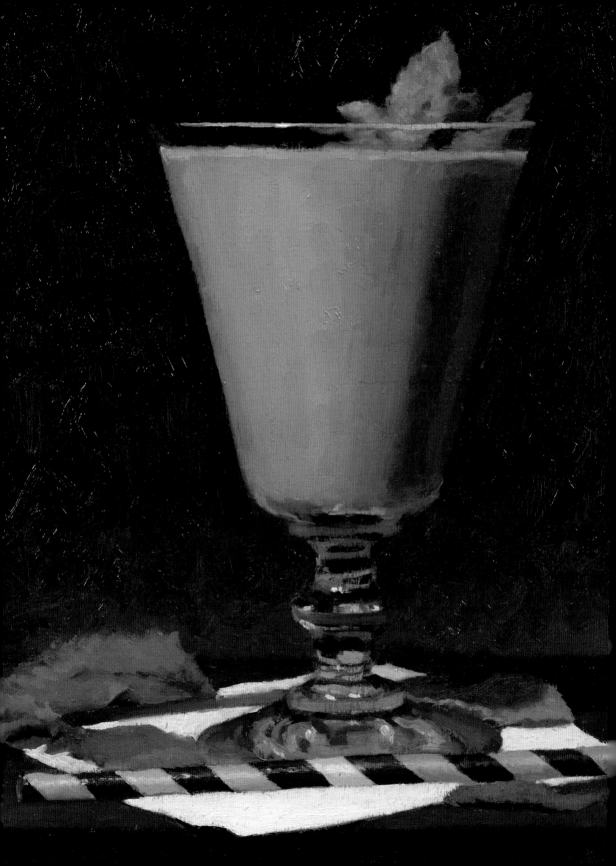

Grasshopper

When the Grasshopper was invented in the French Quarter of New Orleans in 1918, it was already an endangered species. That year, the states were ratifying the Eighteenth Amendment to the Constitution, which would prohibit the manufacture, sale, and transportation of alcohol across the country. And though Louisiana itself ratified the amendment in August, the citizens of the Crescent City were in deep denial about Prohibition. Even people who knew it was in the cards thought it would be unenforceable and that nothing would really change. To some degree, they were right.

Perhaps the Grasshopper was a sign of New Orleanians' bargaining with the inevitability of Prohibition since it's a remarkably temperate drink, made with liqueurs roughly half as potent as your average spirit. And perhaps that's how the drink—one of the last classics to be invented in America before the booze ban—managed to survive the lean years and stage a powerful comeback in the 1970s.

Of late, the Grasshopper has had another small comeback, thanks to Jeffrey Morgenthaler, a bartender in Portland, Oregon, who added ice cream and Fernet-Branca and turned it into a proper boozy milkshake.

SERVES ONE

* 8 ounces crushed ice
* 4 ounces vanilla ice cream
* 1½ ounces green crème de menthe
* 1½ ounces crème de cacao
* 1 ounce heavy whipping cream
* 1 teaspoon Fernet-Branca
* Pinch of sea salt
* Mint sprig, for garnish

Place all ingredients except the mint in a blender and blend on high for 30 seconds. Pour into a large glass and garnish with the sprig of mint.

Brandy Alexander

"It was my first night on Brandy Alexanders," former Beatle John Lennon would later recall about the evening he and singer-songwriter Harry Nilsson were thrown out of the Troubadour nightclub in West Hollywood for heckling the Smothers Brothers comedy duo.

Despite their being tossed out of the club, the party was far from over for the pair, who went on to what can only be described as a three-day Brandy Alexander spree. Although it's hardly fair to blame the drink for everything they did on their 1974 "Lost Weekend," we will grant that it's a deceptively innocent and exceptionally easy-drinking cocktail. Lennon described the drink as "milkshake-like," a quality that was certainly key to its meteoric rise in the 1970s and 1980s—an era when stiff, spirit-forward cocktails lost out to spiked ice cream drinks and, of course, bubbly Lambrusco wine.

SERVES ONE

* 1 ounce brandy
* 1 ounce heavy cream
* ¾ ounce dark crème de cacao
* Freshly grated nutmeg, for garnish

Place all ingredients except the nutmeg in a cocktail shaker over ice. Shake well and strain into a chilled coupe or cocktail glass. Sprinkle nutmeg on top.

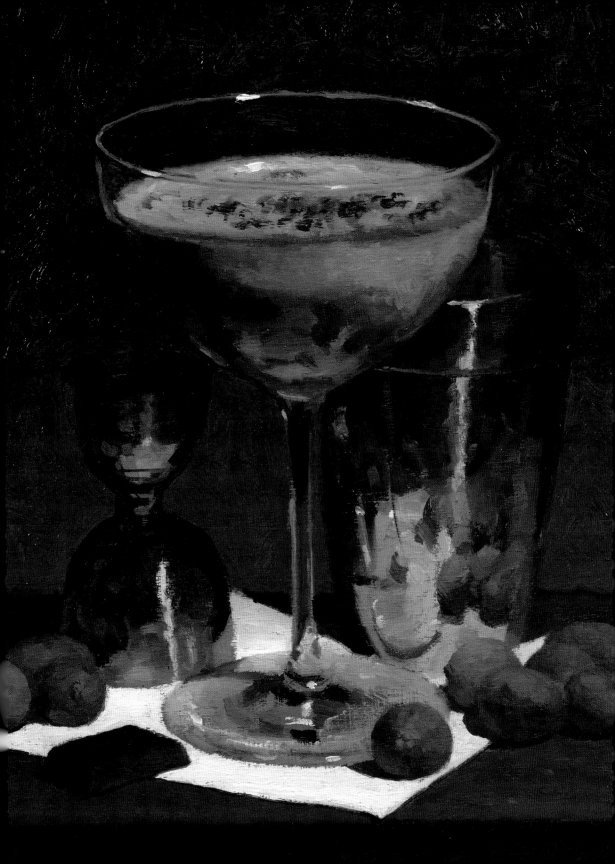

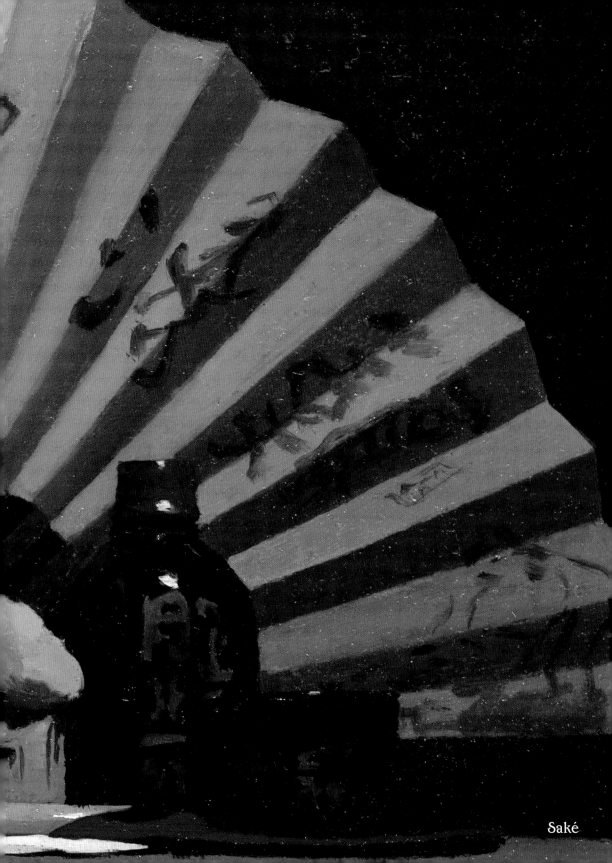

Saké

Saké

Wine lovers might expect that the first lesson in Saké 101 would be to learn all about the nine different varieties of rice used in the brewing process. In fact, though, the specific type of rice is generally far less important than its "polish"—how much husk has been removed from the grain during the milling process.

The husk contains proteins and fats, so if you remove most (or all) of it, what you're left with is the essence of the rice—pure starch. Bottles of saké that read *daiginjō* (high polish) are generally considered the gold standard, since half the weight of each grain of rice has been polished away. The result is a cleaner, more delicate expression of saké.

Of course, just as with everything else, tastes change and established hierarchies are upended with every new generation. Today's up-and-coming saké authorities are championing rougher-tasting brews; in 2018, at a blind tasting held in Paris, a lowly *junmai*, brewed from low-polish rice, took top honors.

Todd's painting on the previous page shows a traditional presentation of saké, but a lot of people don't care for the taste of heated saké. For them, we include a more approachable cocktail, the Saketini.

Saketini

SERVES ONE

* 1½ ounces *junmai* saké
* 1½ ounces vodka
* Cucumber ribbon, for garnish

Stir saké and vodka together over ice in a mixing glass. Strain into a chilled coupe or cocktail glass and garnish with the cucumber ribbon.

Some Don't Like It Hot

It's a myth that saké is always served warm. The most aromatic expressions shine their brightest when served around the same temperature as a chilled lager beer. Dry saké and expressions with a pronounced rice flavor are usually the best candidates for warming.

Although it's not always easy to know the correct temperature for each saké, the options are laid out according to a very precise scale, ranging from *mizore-zake* (slushy cold) to *tobikirikan* (very hot) so, when you order your saké, you can specify the temperature at which you want it served, sort of like specifying whether you want your steak bloody rare, just slightly pink inside, or totally cooked through. Here are the standard recommendations:

Tobikirikan (piping hot) 133°F	**Atsukan** (hot) 122°F
Jokan (slightly hot) 113°F	**Nurukan** (warm) 104°F
Hitohadakan (body temperature) 95°F	**Hinatakan** (sunlight warmed) 86°F
Jo-on (room temperature) 68°F	**Suzuhie** (cool autumn breeze) 59°F
Hanahie (chilled spring flower) 51°F	**Yukihie** (snow cold) 41°F
Mizore-zake (slushy) 23°F	

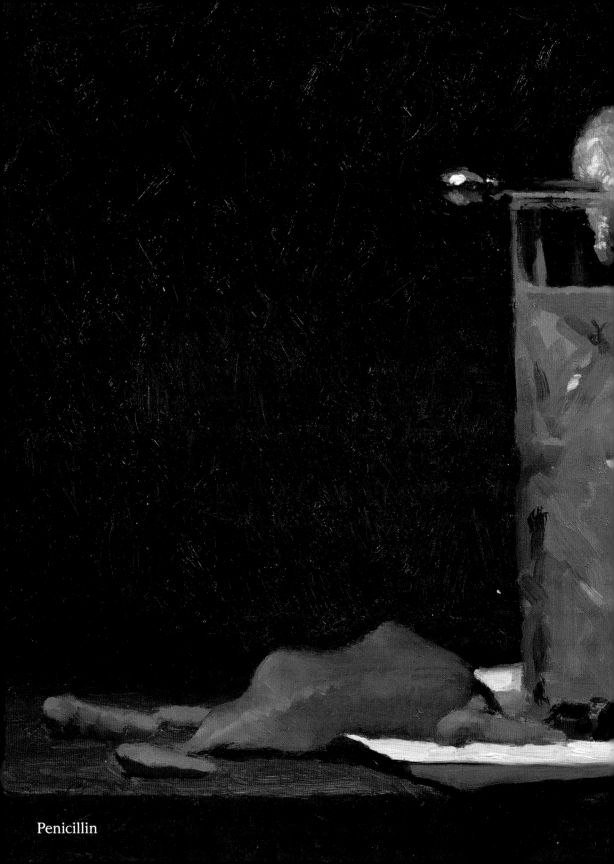

Penicillin

Penicillin

"Penicillin" is a pretty great name for a cocktail, especially when the drink in question is essentially an icy version of a hot toddy (which many people still use to treat the sniffles).

Although in retrospect the drink's name and concept seem obvious, the Penicillin was novel and provocative when it was invented by New York bartender Sam Ross in 2005. Finished with an Islay whisky float, it was one of the first craft cocktails to prominently (and successfully) feature a peaty single-malt scotch.

What's wrong with peat? Not a thing from our point of view. The intense smoke, salt, and medicinal notes left over from the malting process are qualities we can't get enough of, though they do take some getting used to. For those who haven't acquired this esoteric taste, using a peaty single malt can be a deal-breaker. Somehow, though, Ross sensed that it was the right time and place to introduce this novelty. And he was right. It was inducted into the canon of modern classics almost immediately.

SERVES ONE

* 3 slices fresh ginger
* ¾ ounce honey syrup (see recipe note)
* ¾ ounce fresh lemon juice
* 2 ounces blended scotch whisky
* ¼ ounce Bowmore 12-year-old single-malt scotch
* 2 to 3 slices candied ginger, for garnish

Muddle the fresh ginger and honey syrup in a cocktail shaker. Add lemon juice and blended whisky and shake over ice. Double strain (use a fine-mesh strainer in addition to the one on the shaker to remove all bits of ginger) into a rocks glass with fresh ice. Using a barspoon, slowly pour the Bowmore whisky over the drink so that it floats and shows off its peaty aroma. Garnish with candied ginger, on a skewer.

Recipe note: Honey syrup can be made by gently heating equal parts honey and water in a saucepan until the honey has dissolved. Allow to cool before using. Bottle leftover syrup and refrigerate for up to 2 weeks.

Alcohol as Medicine

Whether it's *baijiu* from China, jenever from the Netherlands (the so-called Dutch courage), absinthe from Switzerland, Italian bitters, or just plain quaffing wine, virtually any modern alcohol started out as a medicine. Not particularly *effective* medicine, but it's easy to understand why people thought it worked. Better than any placebo, alcohol was thought to be curative because it made the pain go away.

Although the idea seems premodern, alcohol was still considered to have healing properties until remarkably recently. During Prohibition, doctors actually wrote prescriptions for "medicinal whiskey," a practice that helped a few distilleries survive the dry years *and* took the sting out of the alcohol ban for quite a few "patients," who filled their scrip at the local pharmacy.

The Prohibition era (1920–1933), however, was also when the medical establishment moved away from using alcohol as medicine. When the booze ban was over, few doctors went back to prescribing hooch to their patients. It took longer to convince the general population that there wasn't something curative about alcohol, which is probably why so many of us still turn to a hot toddy when we have a sore throat.

Sidecar

As if France and England didn't have enough cultural differences and petty beefs with each other, they can't even agree on the right way to make a Sidecar. There is, quite literally, a "French School" and an "English School," and neither, of course, can agree on where the cocktail was invented: Paris or London?

The French School calls for equal parts brandy, Cointreau, and lemon juice; the Brits insist that we double the brandy, because that's what the *Savoy Cocktail Book* commands. Both methods actually produce pretty good drinks and, to be fair, much depends on the specific bottle of brandy you're using, since many brandies quietly contain sugar, which blenders add to retain consistency from year to year.

We somehow feel the need to choose sides, however. And so we go with the French School and the original formula that would have guided the bartenders in 1920s Paris, since the drink is synonymous with that time and place, regardless of where it might have been invented.

SERVES ONE

* 1 ounce brandy
* 1 ounce Cointreau
* 1 ounce fresh lemon juice
* Orange twist, for garnish

Pour all the liquid ingredients into a cocktail shaker over ice. Shake and strain into a coupe or cocktail glass. Garnish with the orange twist. (Note: Some people like to rim the glass with sugar, a practice dating from the 1930s. If you like that sort of thing, you do you.)

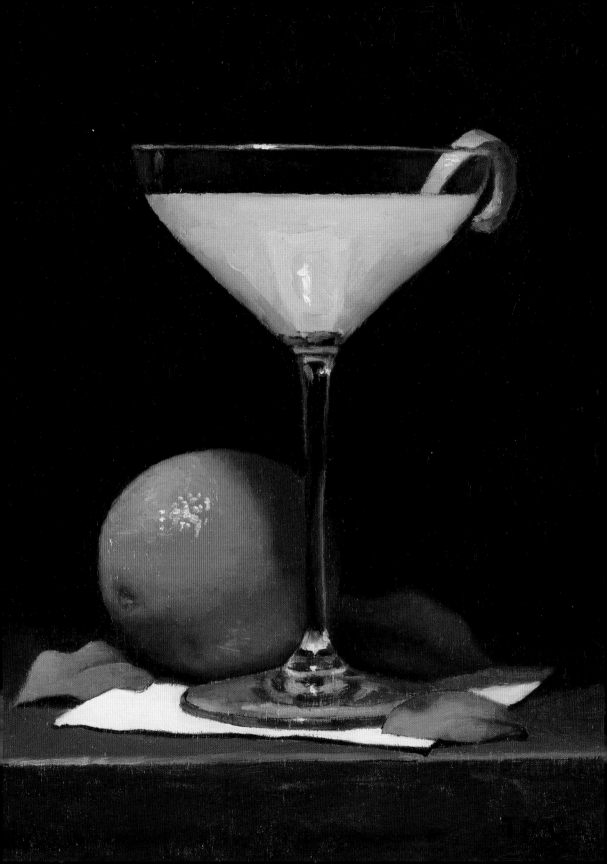

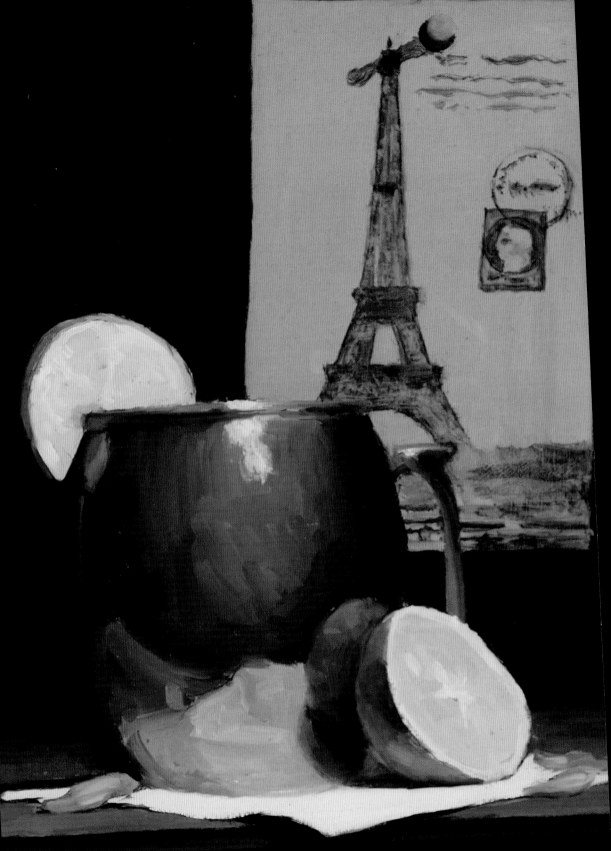

Paris in the 1920s

Paris is always great. After all, it's Paris. The years between World War I and the Great Depression, however, were particularly dazzling. After the hardships of the war, Paris emerged to become nothing less than the cultural center of the Western world.

The Great War, it is said, was so awful that it actually reversed people's faith in the idea of human progress. When it was over, people didn't snap back to anything like optimism, but they did embrace this "second chance" at civilization with a new sense of urgency, wild abandon, and, as historian Ann Douglas characterized life in the Jazz Age, a mantra of "terrible honesty." The new Parisians lived life like there was little left to lose and embraced the stark modernity of *les années folles*.

Those "crazy years" were a lively, iconoclastic era of ideas—and of the liquor that flowed and flowed, fueling the twenty-four-hour cocktail party. It was an era for the ages. But it's not lost in the past. Such explosions of culture—music, art, literature, and the rest— happen when we've seen the worst and realize that we have no choice but to press on and celebrate life, in all its contradictions. The awfulness is merely part of the package. It's only life. And it might be all we get. So let's keep dancing.

Pousse-Café

The Pousse-Café is billed as an after-dinner digestif, but it's really more of a spectacle than a drink. Making one involves carefully pouring several different kinds and colors of liquor one atop the other so that they remain separate in the glass—a trick made possible by the different specific gravities of each. Although the name—which translates as "coffee-pusher"—has come to refer to a variety of layered drinks, the original recipe involves grenadine syrup, three liqueurs, yellow Chartreuse, and brandy—which is a *lot* of sugar to ingest before bed.

We're in awe of this labor-intensive drink's staying power, given that few bartenders enjoy making it and even fewer patrons enjoy drinking it. But with nearly two centuries of history under its belt, the Pousse-Café isn't just a novelty or a practical joke that mean people play on bartenders. It is, instead, an enduring reminder of the importance of frivolity and of human beings' shared love of doing ridiculous things just because we can.

SERVES ONE

* ¼ ounce grenadine
* ¼ ounce maraschino liqueur
* ¼ ounce green crème de menthe
* ¼ ounce crème de violette
* ¼ ounce yellow Chartreuse
* ¼ ounce brandy

Pour the grenadine into a pousse-café glass or other stemmed glass. Pouring each over the back of a mixing spoon, carefully layer the other ingredients, one on top of the other, in the order given. (It may be helpful to watch a YouTube video before attempting this.)

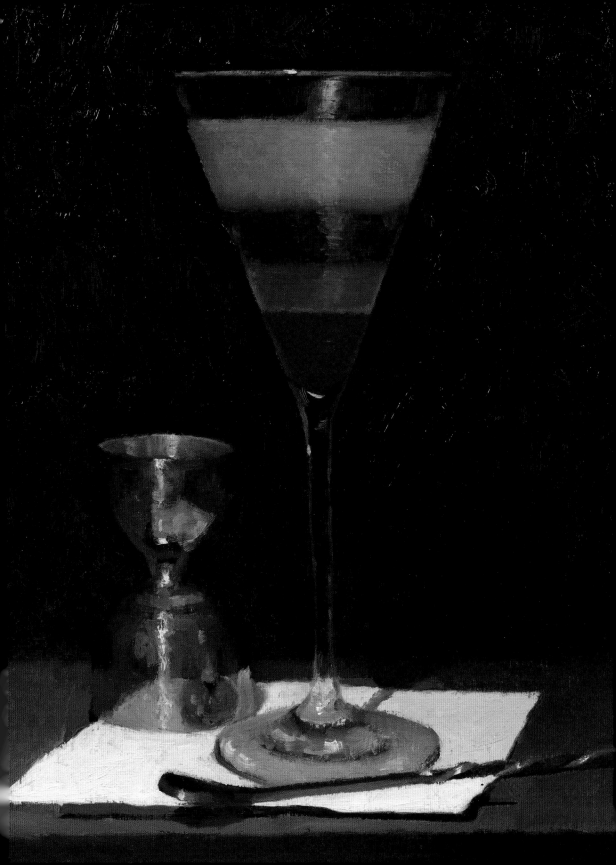

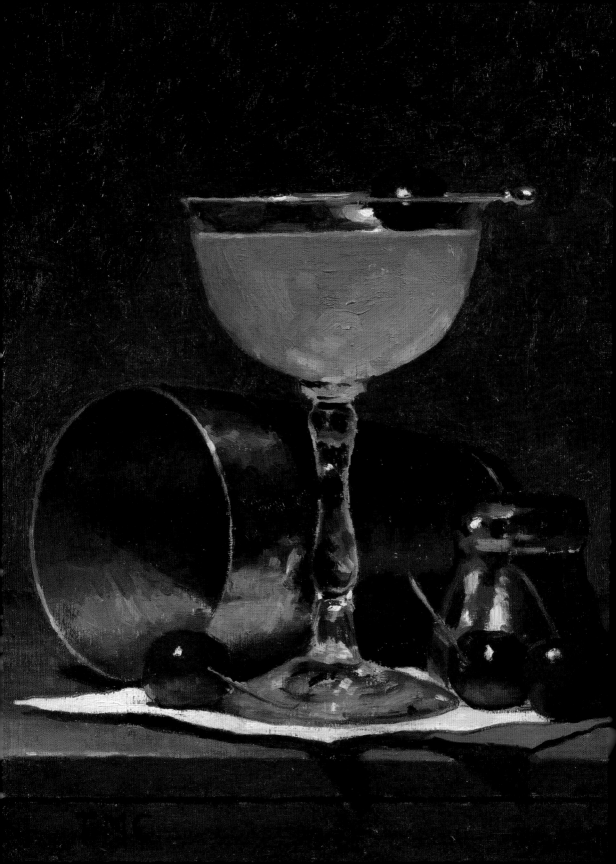

Epilogue: The Last Word

Not many classic cocktails were invented in Motor City, but that is exactly where the Last Word comes from—specifically, the Detroit Athletic Club, circa 1916. People often speculate that the drink was kept alive at the club during Prohibition, when it was made with horrible bathtub gin, ignoring the fact that green Chartreuse and maraschino liqueur would at the time have been even harder to procure than a steady supply of decent gin. (Without those two ingredients, the drink is just gin and juice.)

Ted Saucier, a publicist for the Waldorf-Astoria Hotel, recalled the drink from pre-Prohibition days and included the recipe in his 1951 book *Bottoms Up*, a salacious volume full of cocktail recipes and full-color paintings of (mostly tasteful) semi-nude pinup girls. The illustrators—guys like Bradshaw Crandell, Ben Stahl, Earl Cordrey, and John La Gatta—were all household names at the time, thanks to their work for the *Saturday Evening Post* and other popular magazines.

Half a century later, the Last Word was rediscovered by legendary Seattle bartender Murray Stenson, who decided it deserved a second chance and put it on the cocktail menu at the Zig Zag Café. Even though this pale green drink sounds awful on paper, it's surprisingly delicious in real life. It was a hit in the Emerald City and, soon after, everywhere else.

Thanks, Detroit. We owe you a drink.

SERVES ONE

* ¾ ounce gin
* ¾ ounce green Chartreuse
* ¾ ounce maraschino liqueur
* ¾ ounce fresh lime juice
* Maraschino cherry, for garnish

Pour all the liquid ingredients in a cocktail shaker over ice. Shake well and strain into a chilled coupe or cocktail glass. Garnish with the cherry.

Index

About the Authors

Todd M. Casey is the author of *The Art of Still Life: A Contemporary Guide to Classical Techniques, Composition, Drawing, and Painting in Oil* (Monacelli Studio, 2020) and *The Oil Painter's Color Handbook: A Contemporary Guide to Color Mixing, Pigments, Palettes, and Composition* (Monacelli Studio, 2022). A Massachusetts native, Todd studied at art schools in Boston and San Francisco before embarking on the classical artistic education offered by Jacob Collins's famed Water Street Atelier in New York City. A modern master of the still-life genre, Todd teaches at several institutions, including the Art Students League of New York. He is represented by Rehs Contemporary Galleries, Inc., New York, and his paintings are held in numerous private collections worldwide. He lives with his wife and daughter in Connecticut. Visit Todd's website at toddmcasey.com.

Christine Sismondo has been writing about wine, spirits, cocktails, and other topics, ranging from fine art to social history, for the *Toronto Star*, the *Globe and Mail*, *Maclean's*, and other publications for more than twenty years. She is also the author of *America Walks into a Bar: A Spirited History of Taverns and Saloons, Speakeasies and Grog Shops* (Oxford, 2011) and a six-part podcast series on Prohibition for Wondery's *American History Tellers*. Her most recent book, coauthored with Stephen Beaumont, is *Canadian Spirits: The Essential Cross-Country Guide to Distilleries, Their Spirits, and Where to Imbibe Them* (Nimbus Publishing, 2019). Christine lives in Toronto.

James Waller is the author of the *Drinkology* series of books published by Abrams. The series' first volume, *Drinkology: The Art and Science of the Cocktail* (2003; rev. ed., 2010), has sold more than 80,000 copies and has been translated into Italian. He has often blogged about spirits, wine, and beer and has conducted cocktail-making demonstrations in cities across the United States. Besides working as a freelance writer and editor, James is a painter and printmaker; his artwork can be seen at jameswallerart.com. He lives in Baltimore, Maryland.